GHOSTS OF ALEXANDRIA

GHOSTS OF ALEXANDRIA

MICHAEL LEE POPE

Published by Haunted America

A Division of The History Press

Charleston, SC 29403

www.historypress.net

Cover image: Front cover photo by Louise Krafft.

First published 2010

Manufactured in the United States

ISBN 978.1.59629.958.0

Library of Congress Cataloging-in-Publication Data

Pope, Michael Lee.
Ghosts of Alexandria / Michael Lee Pope.
p. cm.
Includes bibliographical references (p.).
ISBN 978-1-59629-958-0
1. Ghosts--Virginia--Alexandria. 2. Haunted places--Virginia--Alexandria. I. Title.
BF1472.U6P667 2010
133.109755'296--dc22
2010028269

CONTENTS

ACKNOWLEDGEMENTS

I would like to start by thanking the many people who took time to share their experiences and stories with me. This book would not be possible without them. Others I would like to thank include the following:

My parents, Shooter and Diana Pope. They gave me everything.

My lovely wife, Hope Nelson. She has the patience of a saint, the killer instincts of a skillful copy editor and a heart of gold.

Wellington Watts, owner of Alexandria Colonial Tours. His guidance and friendship have been invaluable.

Ken Balbuena, tour guide and friend. His research skills and storytelling skills are second to none.

Louise Krafft, the best damn photographer in Virginia.

George Combs, director of the Alexandria Library's Special Collections. He knows where all the bodies are buried.

INTRODUCTION

LOWDOWN ON THE COLONIAL TOWN

Don't look now, but there might be a ghost standing next to you. You looked, didn't you? What's that, you say? Didn't see anything? Well, that doesn't mean there wasn't a ghost standing there. It may only mean you didn't *really* look.

Ghosts are everywhere. They're in our dreams and in our basements. They live in the past yet creep into the present. They loom over important times, and they're with us during the most mundane moments. And it really doesn't matter whether you believe in them or not. Ghosts are here to stay. As William Faulkner once observed, "The past is never dead. It's not even past."

No, the past is not dead. It's here with us, just like that ghost standing next to you right now. Maybe he's a prehistoric hunter who used a stone tool to kill a mastodon thirteen thousand years ago. Or maybe she was from a moneyed family that helped pay the bills during the startup phase of the city. Perhaps he's a spy for the American cause. Then again, she could be a star-crossed lover who found herself horribly burned in an unexpected fire. Or her fiancé, suicidal with grief and armed with the means to do something about it.

These are the ghosts that are around us every day in Alexandria. All we have to do is take the time recognize them.

From its humble origins as a tobacco port hugging the southern shore of the serpentine Potomac River, Alexandria, Virginia, has been at the crossroads of time and tide. Here was where a teenaged surveyor by the

name of George Washington helped lay out the city streets. Here was where a British general launched a disastrously unsuccessful invasion into the French-controlled interior of North America. Here was where men with black cockades in their tricorns celebrated independence. And here was where the early republic found triumph and tragedy among the twice-blooming wisteria and stately headstones.

Perhaps it was the "Narrative of John Trust" that put it best, in a vivid description of an occult scene revealing the identity of the infamous Female Stranger: "What I had seen excited me strangely...Ghosts of dead hopes, half memories and half dreams haunted me."

Spoiler alert: The following pages will reveal the identity of the Female Stranger. They will explain why the Swope House suddenly became haunted in the 1850s, long after the death of Michael Swope. They will unveil the secrets of City Hall. And they will plunge the depths of Yates Gardens, where people are still fighting over what happened—or what didn't happen—in 1798.

What follows is a compilation of some of Alexandria's most famous ghost stories. It's not intended to be comprehensive, and there are many more ghost stories lurking around Old Town. Each of the chapters blends archival research with modern-day interviews, essentially blending historical fact with opinion and perspective. Hopefully, you'll walk away from the book with an appreciation for the ghosts that are all around you. And you'll realize that Alexandria is, in fact, a city that's haunted by its past.

CHAPTER I

GHOST OF A SPOOK

GRUDGE LINGERS IN THE AFTERLIFE

Alexandria's most notorious ghost has carried a grudge for centuries, haunting the house at 210 Prince Street with a particular hatred for all things British. Some say that the ghost here is an American hero who began haunting the house after his grave was disinterred. Others say that the ghost is a spy who was executed by the British. In any event, it's one of the most talked-about ghost stories in Old Town.

"I don't normally believe in ghosts," said Virginia Rocen (who purchased the house with her husband, Donald Rochen) in a 2006 interview with the author. "But I could change my mind if I heard something. Couldn't we all?"

The house looks much the same today as it did two hundred years ago. Basement windows peer into the street from below, and a hand-carved doorway beckons visitors. The windows have the romantically flawed sense of distortion, indicating original material or something replicating the aesthetic. A mysterious garden is guarded by a red brick wall as shadows gather in a pitch-black archway that's almost invisible from the street. From all appearances, something is lurking at 210 Prince Street.

This house is haunted.

Various versions of the legend have emerged over the years. One says that the ghost is Colonel Michael Swope, a commander of a Pennsylvania brigade who was captured during the war and later released in a swap for Loyalist William Franklin—the son of Benjamin Franklin. Another version identified the ghost as John Dixon, a wealthy Alexandria merchant who joined

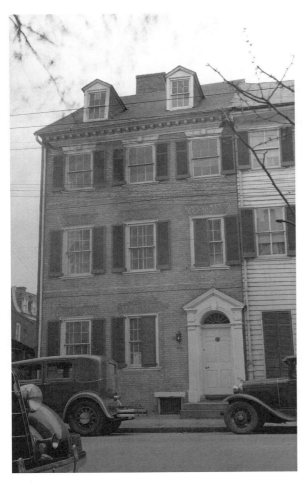

the militia and was executed by the British as a spy. Interestingly, each version of the story presents a tension between Loyalists and rebels.

"If a ghost is seen by only one person, you have to question either the authenticity of the ghost or the veracity of the teller of the tale," explained historian Ruth Lincoln Kaye in *Legends and Folk Tales of Old Alexandria*. "But when a ghost is seen many times over a number of years—who wants to be the first to dispute its existence?"

In the beginning, this tract of muddy land was part of the original 1749 auction. According to the *Alexandria Gazette*, the original sale took place for fifteen pistoles on July 14, 1749. Considering the land where the house now stands is valued at $600,000, exchanging a handful of Spanish gold pieces seems like a bargain. But the landowner failed to seal the deal.

The Swope House is home to one of the most notorious ghosts in Old Town, one with a hatred for all things British. *Library of Congress.*

This was a time when the city leaders wanted to encourage landowners to begin construction as soon as possible. Alexandria was a questionable startup seaport without much of an identity, set in a Virginia wilderness, and rules were designed to force the landed class to build within two years or forfeit their property. Empty lots served no one. And so it was that the poor soul who threw down fifteen pistoles lost his investment when the

government acquired the property by eminent domain and returned it to the open market.

On June 18, 1754, the property was sold to Alexandria founding father William Ramsay—one of the city's first mayors and owner of several other significant properties in town. He laid down thirty-six and a half pistoles, a "sharp advance in value" from its original selling price according to one account published in the newspaper. Yet the record does not indicate any construction at the site until 1784. That's when a man by the name of Michael Swope enters the picture.

"Swope was a true patriot," said Wellington Watts, owner of Alexandria Colonial Tours. "Here's a man who is a real hero of his day, someone who was admired and revered."

Swope's story is chronicled in Heitman's Register of Revolutionary Officers, Saffel's Lists of Revolutionary Soldiers, records of the United States War Department and documents in the Pennsylvania archives. His father came to America in 1720 from Wurtenburg to settle in a corner of Lancaster County known as Swope's Knob, now known as Conner Spring.

Michael Swope became an active participant in the Pennsylvania rebellion. As early as 1774, he was a member of the York County Committee of Observation. The next year, he joined the Safety Committee and later became a colonel of the First Battalion, First Brigade, of the Pennsylvania Flying Camp. While Michael Swope was at war, he wife kept the Swope Inn on West Market Street in York, where President of Congress John Hancock entertained friends while visiting York.

In the fall of 1776, the rebels suffered the most serious loss of York County troops during the Revolution at the Battle of Fort Washington, which took place in the northern part of what is now New York City. In November, it was attacked by a large force of English and Hessian troops. Colonel Robert Magaw ordered Swope to defend the approaches to the fort. But that's not how things worked out. On November 16, 1776, Swope was apparently captured at Fort Washington in New York and held for years as a prisoner of war.

"Terms of surrender were offered by the enemy, but Swope refused," wrote York County historian George Prowell. "A furious contest ensued when the gallant colonel and 400 of his York County soldiers were killed, wounded or became prisoners of war."

Swope lived in captivity for years on a prison barge in New York Harbor before the British indicated that they were "willing that Colonel Swope be returned for Governor Franklin." That would be William Franklin, who

was governor of New Jersey and was taken into custody by the Provincial Congress of New Jersey in 1776. But the exchange didn't take place—at least not until several years later, and Franklin may not even have been part of the deal. During time in captivity, the British captured Philadelphia, and the Continental Congress moved to a little town in Pennsylvania known as York—Swope's hometown.

"When he was imprisoned in the British ship, he was treated miserably," explains Watts. "So he built up an even healthier anger against his old enemy."

When Swope was finally released, the story goes, he was forced to walk all the way to Alexandria, hundreds of miles and after suffering years of captivity. After the war, Swope appears in Alexandria in 1784. His life after the war is not as well chronicled. Some accounts say that Swope and his sons became chandlers, shining a light on the postwar boom that the city was experiencing. Others say that he opened a riverfront warehouse and began a shipping business to Barbados and beyond. Whatever became of his professional situation, his personal life appears to have followed the old maxim about good fences making good neighbors.

According to an item in the *Alexandria Gazette*, he and a neighbor split the cost of a thirty-six-pound, six-shilling garden wall separating their properties—a wall that survives to this day, proving that this was a time when things were built to last. The house itself is a fine example of architecture from the era, with fine hand-carved moldings. People say that he loved the third floor best, as well as the music room and the library.

He died in 1809. But that's not the end of the story for Michael Swope. His body was apparently hauled by carriage to a ship lying off Union Street. From there, it set sail for Philadelphia. There, he was laid to rest in the family vault. But Swope would not rest in peace. In 1859, a yellow fever epidemic swept through Philadelphia. The health officer ordered the Swope family vault to be disinterred. That's when the haunting began.

The first report of a ghost at the house took place in 1859. Perhaps the rising tension between North and South provoked old rivalries. Or maybe earlier sightings went unreported. Maybe, just maybe, the reason the ghosts started haunting the house in 1859 is because that's when Swope's body was unearthed. Whatever the reason, this was when people realized that the building was more than a historic home. The house was most definitely haunted.

"When his grave was moved, that's when the haunting began," said Watts. "That's when the ghost of Michael Swope came back to the house and started haunting it."

The archive at the city's library is full of stories about 210 Prince Street. In some of the old newspaper clippings, neighbors have reported music playing when nobody was home. Others have described a "hostile, bone-chilling cold spot" on the stairwell. Some have described feeling the presence of a man when alone in the house. On one occasion, a young woman reported seeing a man walking through the hall wearing an American uniform from the Revolutionary War.

"The startled witness, obliged to future history, chased the spy into the music room, where he was nowhere to be seen," wrote Eric Segal in his 1975 study of Alexandria ghosts. "To this day, neighbors often speak of hearing someone play the piano when there is no one home."

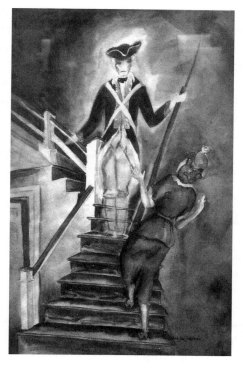

A 1956 painting by artist Babs Van Swearingen features a ghostly colonial soldier descending the stairwell of the Swope House. *Alexandria Lyceum.*

The most famous appearance of the ghost took place in the 1930s, when a real estate agent was showing the home to a visiting British woman. The tour began spectacularly enough, with the woman starting in the impressive root cellar. She then walked through the grand living room and the opulent dining room on the first floor. The pair moved upstairs, seeing the second-floor bedrooms.

"The Realtor and the owner had no trouble going up the stairs to inspect the upper floors," wrote Angela Soper in a 1989 article for the *Alexandria Gazette Packet*. "But the lady from England had trouble."

When the real estate agent attempted to take the woman up to the third floor, something—or someone—stopped her dead in her tracks. Was it the ghost of Michael Swope? Perhaps it was the specter of John Dixon. Whatever the identity of the ghostly force, she was unable to overcome the apparition. Unable to see the third floor, the British woman explained that she could not purchase the house.

"I'd love to buy the house, but something is preventing it," she is reported to have told the real estate agent. "I'm very psychic, and I can tell you there is definitely a ghost in this house—one that, for one reason or another, does not like me."

That's not the only story of the ghost having an anti-British bias. Ghost tour guide Amanda Allen said that she was walking near the house when she heard another guide explain the famous story about the British woman who was turned away by the ghost. The other guide concluded the story and then warned the crowd that British people should be careful walking by the house.

"Just then, a woman tripped in front of it," said Allen. "Coincidence?"

The house at 210 Prince Street has long been at the center of attention. Aside from being on a prominent street across from the Athenaeum, it's also been featured in countless ghost stories. It was also the home of one of Alexandria's most notable local historians, Ethelyn Cox, author of *Historic Alexandria Virginia Street by Street*. In a 1965 interview with the *Washington Star*, Cox was skeptical.

"Mrs. Hugh B. Cox says she's never seen a ghost," wrote reporter and longtime Alexandria resident Frances Lide. "So she can't vouch for the tales of a Revolutionary solider said to haunt the old Alexandria house in which she and her husband have lived for the past 17 years."

But that doesn't mean it didn't exist. The infamous story of the British woman's tour being stopped by a ghost is so famous that it has been immortalized by artist Babs Van Swearingen. She chose the famous story as one of several for a series of watercolor paintings based on well-known ghost stories of Old Town. Because the story of the British woman and the real estate agent had been told and retold so many times, Van Swearingen knew that it would be perfect material for a spooky watercolor. She later explained that her ghost series had a style unlike her other paintings because her hand seemed guided, almost as if by automatic writing.

"I can't paint a ghost unless I can see it," Van Swearingen told *Washington Post* reporter Frances Lide in 1956.

Stories of the ghost at Prince Street have lingered for years, with a number of variations. One version of the story has Swope as an extremely hospitable host, as long as you're not British. Another alternative has the ghost come down the stairs, go along the hall and disappear into the music room. According to one account, the ghost of Swope has been known to answer the door of the house during dinner parties in full military dress from the Revolutionary War.

"He'll take their coat and ask for their drink orders," says Watts. "But then he never comes back with the drink."

Watts says that the guests will then complain to the owners of 210 Prince Street that they never got their drink from the butler. Astonished, the homeowners will say that they don't have a butler. The guest will then describe the colonial soldier who answered the door and took their drink order. Eventually, the guest will get their pinot noir, and the evening will go off without a hitch, except for that spooky appearance of the ghost of Michael Swope.

"He's probably not a very good butler," Watts says with a smile.

Tour guide Barbara McAdams says that she was leading a tour through Old Town several years ago and brought a group to the Swope House. Just as she began to explain the well-known story of the ghost haunting the house, a man came out of the house with his daughter in hand. The pair paused to listen to McAdams's version of events. After she was through, something strange happened.

"Daddy," the girl said loudly, according to McAdams. "I've seen the ghost!"

Incredulous, the father couldn't believe what he was hearing. He asked his daughter if she was sure, and she said that she was. Then the girl proceeded to

The spooky Swope House has long been featured by the city's ghost tour guides. *Photo by Louise Krafft.*

give an uncannily detailed description of a colonial soldier, down to every last detail of buff and blue. McAdams said that the girl described Swope perfectly.

"And she had never seen a picture of him," said McAdams. "Oh, that was weird."

One popular variation is that the ghost is a mysterious man by the name of John Dixon, who is haunting 210 Prince Street. Little is known about Dixon, other his position as a wealthy Alexandrian before the war. During the war, folks say, he was executed by the British as a spy. Washington is full of spooks, of course. But here's a house that could be haunted by the ghost of a spook.

"Conjecture, Old Town's most reliable source, would identify the ghost as an American spy executed by the British during the American Revolution," explained Hal Feldhaus in a 1985 article for the *Old Town Crier*.

Others obviously agree with the conjecture. "If life after death exists," mused Segal, "certainly no one in such an afterlife would hold any lost love for his executioners, and history indicates that John Dixon was *and is* no exception."

Down the block a few doors, there's another house with a spooky history—spying, that is. It's a red brick building on the same side of the street a few doors down from the Swope House. During the War of 1812, two British spies were captured and taken into custody in Alexandria. Instead of being shot, they were executed by hanging. But they weren't hanged in Market Square. Instead, they were taken here to this house on Prince Street. There, in the living room, the two spies were executed. Their bodies were apparently left there to send a message to the British when they invaded the city in 1814.

"When they burst into the house to raid it, they found the spies hanging there," said ghost tour guide Wellington Watts. "Those ghosts are still haunting that house."

Watts hadn't heard the story until recently, when a little boy who lived in the house came and told him all about it three or four years ago. After Watts finished his tours for the evening, the kid approached the tour guide and explained the whole story. The shocking tale was complete with gruesome details, including how the boy still sees the ghosts of the British spies hanging around in the living room.

"It was kind of like the *Sixth Sense*," said Watts, referring to the 1999 movie. "This kid saw dead people."

LEGEND OF THE FEMALE STRANGER

WHO IS BURIED IN THIS ANONYMOUS GRAVE

The elaborate inscription on the grave bears no name, no hint as to who may have been buried beneath the tabletop tombstone. The name has not been erased from centuries of wind and rain. It was never there at all. Instead, the epitaph is dedicated to the memory of a "Female Stranger," an inexplicable monument to an unknown woman.

"I suppose it's sort of like a crossword puzzle," explained city historian Michael Miller. "You don't want to leave it until you've solved the puzzle."

The pieces of this puzzle date back to the early nineteenth century, when a mysterious couple arrived at the port of Alexandria. Over the years, many theories have emerged about who this couple may have been. Although there are many theories and a handful of clues, no one is sure about who they were or why they came here or what was the purpose of their ambiguity. What is known, however, is that they left behind this mysterious monument in St. Paul's Cemetery, one that brings visitors from all over the world. People speak of its mysteries and conjecture as to its origins.

"Of all the legends and tales of old Alexandria, the most poignant is the mysterious story of the Female Stranger," wrote local historian Ruth Lincoln Kaye. "It's the greatest mystery of them all."

The mystery started in the autumn of 1816, a time when Alexandria was still struggling to recover from a war with England known as the War of 1812—a misleading name seeing as how the invasion and occupation of Alexandria took place in 1814. The city's unconditional surrender made Alexandria the object of scorn and ridicule throughout much of the United

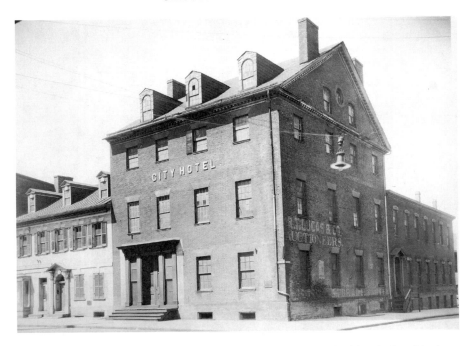

Gadsby's Tavern and City Hotel is one of Alexandria's most popular historic sites. It's also one of the most haunted. *Alexandria Library Local History Special Collections.*

States, giving the city a black eye. A famous political cartoon from the era shows British Johnny Bull presenting Alexandria leaders with terms of capitulation. "I must have all your flour, all your tobacco, all your provisions, all your shops, all your merchandise, everything except your porter and Perry," proclaimed the cartoon embodiment of the British empire. "Keep them out of my sight. I've had enough of them already."

"Pray Mr. Bull," the Alexandrian responds, his hair standing straight on end. "Don't be too hard with us. You know we are always friendly, even in the time of our embargo."

In the background, a British officer calls the Alexandrians "cowards" as he makes off with some rum and tobacco. Clearly, the invasion and occupation of Alexandria is not the kind of thing that shows up in brochures published by the Alexandria Convention and Visitors Association. In many ways, it's one of the darkest and most unknown aspects of the city's history. Unlike the rest of Virginia, which was squarely in support of Jefferson's Democratic Republicans, Alexandria was a Federalist town, and the *Alexandria Gazette* was a Federalist paper. The city's business class had a lingering bitterness for a

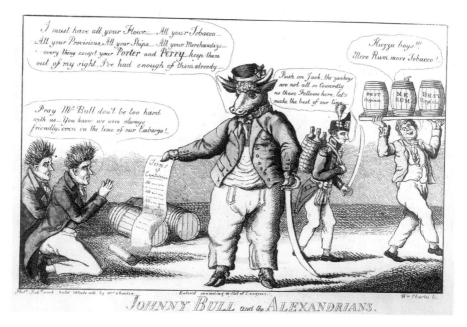

A cartoon from 1814 depicts cowardly Alexandrians helpless against the power of the British empire, personified in the presence of Johnny Bull. *Alexandria Library Local History Special Collections.*

political caucus that imposed an embargo against England, an action that cut into the profits of the seaport's captains of industry. Nearly $100,000 worth of foodstuffs and grain was lost when the British entered the port and began pilfering.

"Besides the financial and monetary losses, Alexandrians were humiliated nationally because they had surrendered the town without a shot," said Miller. "The invasion was a major contributing factor that led to the demise of the seaport of Alexandria."

After the smoke cleared—literally, with the Capitol and White House burned by the British—*Gazette* editor Samuel Snowden was eager to set the record straight about what had happened. In a stinging rebuke of other contemporaneous newspaper coverage of Alexandria's surrender, Snowden sought to dispel the "falsehoods" that he said were "in circulation respecting the late occurrences at this town." Taking issue with what had been reported in a newspaper known as the *Examiner*, Snowden said that the Union Jack was never hoisted above the city and that the townsfolk had no choice but to surrender.

"We can assure the public that the British flag was not hoisted at all by any of [Alexandria's] inhabitants or the British except on board their vessels," Snowden wrote. "The citizens of Alexandria never did desire or contemplate a surrender of their town" but were forced to because the federal government left them defenseless.

This was the setting for Alexandria's most notorious ghost story, the legend of the Female Stranger. It all started when a handsome Englishman arrived from the West Indies and docked at the port of Alexandria. He was with a beautiful woman, but she was terribly ill. The couple traveled up the embankment to the Gadsby's Tavern, where they checked into room number eight. The man hired Samuel Richards, a prominent local doctor, to attend to the woman. But he was not able to help her. Mrs. John Wise and Mrs. James Stuart also attended to the woman. But every day the woman grew closer to death.

She died on October 14. He decided to bury her in Alexandria, borrowing a considerable sum of money from Lawrence Hill, a local merchant, to do so. In exchange, the man gave Hill a note from the Bank of England, a note that was later dishonored when it was discovered to be a forgery. The tombstone has one of the most elaborately engraved inscriptions in the city—and also one of the most unforgettable:

> *To the memory of a FEMALE STRANGER, whose mortal sufferings terminated on the 14th day of October, 1816 aged 23 years and 8 months. This stone was place here by her disconsolate husband, in whose arms she sighed out her last breath, and who under God did his utmost even to soothe the cold, dead ear of death.*

This inscription is followed by a quote from the tenth chapter of the book of Acts, a passage in which the apostle Peter preaches about the divinity of Jesus: "To him give all the prophets witness, that through his name whosoever believeth in him shall receive remission of sins." The monument was originally surrounded by an iron railing, which was later scavenged during the dark days of World War I. According to Miller, who spent years researching the topic, the cost of the burial and the grave was $1,500.

"After receiving the sympathy of his friends, the sorrowful widower departed Alexandria without paying his bills and was never seen again," wrote Miller in a 1983 *Alexandria Port Packet* article about the mystery.

But the story did not end there. A few years later, according to Miller's research, the merchant Lawrence Hill went to New York to enter into a

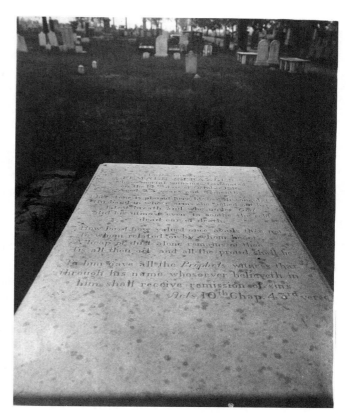

The grave of the Female Stranger is located in St. Paul's Cemetery. *Alexandria Library Local History Special Collections.*

business relationship with his uncle, Robert McCrea, formerly a merchant of Alexandria. While in New York, Hill had occasion to visit Sing Sing prison and was accosted by the same English widower who had previously borrowed money from him in Alexandria.

That man, whose last name was Clermont, had been imprisoned for forgery. He had a shaved head and was employed making shoes for the other inmates. But his polished English demeanor had not been tarnished by prison life. According an October 12, 1861 story in the *Alexandria Gazette*, Hill confronted Clermont at the prison.

"Mr. Clermont, the bills which you gave me were all returned protested and your conduct is most inexplicable," Hill said, according to the newspaper account.

"Ah, indeed," came Clermont's reply. "Well, it was probably owing to some informality, and it will give me pleasure to furnish you with others in their stead."

Hill then came back to Alexandria "absorbed in the contemplation of the adroit and skillful roguery of the polished Mr. Clermont."

Ever since her death in room number eight, the ghost of the Female Stranger has haunted Gadsby's Tavern. She is often seen through the windowpanes from the street, holding a candle. She is seen elsewhere in the building, always holding a candle to announce her presence and shine a light into the darkness of the unknown. Ghost historian L.B. Taylor documented the hauntings in the first installment of his "Ghosts of Virginia" series.

"Visitors have reported seeing her at a bedroom window holding a candle and looking out," Taylor wrote. "Others have sighted her walking the halls, or standing by her tombstone nearby."

For years, tourists have strained their necks to look into the window of room number eight, hoping to see the light from a candle. Others have gathered by her grave in St. Paul's Cemetery. But nobody has been able to solve the mystery, one that continues to intrigue Alexandria. Many people have speculated about her identity, wondering if she might have been the daughter of Aaron Burr, a Napoleonic princess fleeing the political turmoil of Europe or perhaps even a well-to-do unmarried woman who found herself unexpectedly in the family way.

"Maybe some day, we'll find a new piece of evidence and solve the mystery," Miller said. "Until then, we can only speculate."

The legend of the Female Stranger has long haunted Gadsby's Tavern, one of the city's most prominent historic buildings. Don't expect to hear about the Female Stranger on the tour of Gadsby's Tavern Museum, which includes a visit to room number eight. The folks at the city-run museum are much too high-minded for that, preferring to focus the tour on George Washington's preference for canvasback duck or the menu for Thomas Jefferson's inaugural banquet. They'll even tell you about a pig that can add, subtract, multiply and divide. But not the Female Stranger.

"No," explained Liz Williams, assistant director of Gadsby's Tavern museum. "The Female Stranger is *not* on our tour."

Life on the streets is different, obviously. And people who take a ghost tour in Alexandria are almost certain to learn something about this famous mystery, the most famous ghost story in the city and perhaps even the region. Ghost tour guide Ed Michals, who founded the city's oldest ghost tour, knows that Gadsby's Tavern is haunted. As a member of the American Legion, which owned the building for many years, he spent a lot of time in the tavern and the adjacent building, which is the American Legion lodge. Over the years, he says, ghost sightings have been commonplace. Sometimes the

shadowy figures appeared and disappeared. At other times strange noises were heard in the middle of the night.

The most notorious ghost sighting happened during one of the balls that take place each year in the historic ballroom where George Washington once celebrated his last birthday in 1799. This was one of those events where people get dressed up as they did in Washington's day and eat all of Washington's favorite foods and do Washington's favorite dances. Suddenly, one man saw a woman who looked a little out of place. She was not wearing the kind of clothing that a woman might wear in the eighteenth century. She was wearing the clothing that a woman might wear in the early 1800s, about the time the Female Stranger died in room number eight.

"A lot of people don't know anything about the Female Stranger, and they report seeing a woman wearing funny clothing, in other words not modern-day clothing or eighteenth-century clothing," said Michals. "I think it's pretty clear that she continues to haunt the building to this day."

Obscured in the archive is a document that could answer the mystery. It's known as the narrative of John Trust, a document that changed hands several times before being published in the twentieth century by Gadsby's Tavern and City Hotel, then owned by the American Legion. William McNamara was president when the organization republished the narrative of John Trust in the 1960s. As McNamara explains in the introduction, take it for what it is.

"Various versions of the story have been handed down from generation to generation by word of mouth while others have appeared in print," McNamara noted. "The narrative which follows is most intriguing; but is it the true account? We will leave that to your judgment."

The narrative has a Victorian wordiness, alternately flowery and dramatic. Essentially, it explains the Female Stranger in this way: She is Blanche Fordan, daughter of an impoverished single mother who died while giving birth at the almshouse at Truro in Cornwall. She was later adopted and raised in Martinique. After Napoleon fell, two men by the name of John Trust and John Wroe bugged out of Paris and arrived in sunny Martinique.

There in the Caribbean, Trust and Fordan fell deeply in love. He was spellbound by her beauty, entranced as if he were in the presence of majesty. Her eyes shone like diamonds, and her hair "lay in its raven brilliancy." But there was disaster looming in paradise. Wroe was jealous. He wanted the affections of Blanche Fordan for himself.

Here's where Wroe used his powers in the occult arts to mesmerize Fordan and take her aboard a ship headed for America. While she was in a trance

According to the narrative of John Trust, the Female Stranger was a woman named Blanche Fordan. On her deathbed she implored John Wroe to someday find John Trust and tell him it was he she really loved. *Photo by Louise Krafft.*

on the boat, he married her. But by the time the newlyweds arrived on the Alexandria waterfront, she had become gravely ill. Somehow she caught a terrible fever while navigating the Atlantic Ocean.

Their arrival in Alexandria made quite a scene. Apparently, their cover story was that their ship was en route from the West Indies rather than Martinique. Even before they had set foot on solid ground, people in Alexandria were fascinated by this mesmerizing couple. They had a distinguished bearing and the kind of clothing that made people assume they were wealthy and could afford the best Alexandria had to offer. So, of course, they were shown to the City Hotel. This is where the Female Stranger lay on her deathbed, her grip on this world slowly slipping away.

"I shall soon be away far from living fears and evil tongues," said the Female Stranger.

There, on her deathbed, she implored Wroe to some day find Trust and tell him that it was he she really loved. As if that wasn't dramatic enough, the narrative features exotic international locations and a spooky confrontation at the grave of the Female Stranger in St. Paul's Cemetery. The narrative also features a wild occult ritual scene at a pleasure garden known as Broomilawn along Hunting Creek south of Alexandria. At one point in the narrative, Trust sees Wroe at Broomilawn. For some reason, Wroe does not recognize Trust, who follows the occult master as they entered "precincts sacred beyond all searching, because wasted flesh and moldering frames wait there to see God."

"What I had seen excited me strangely," Trust admits. "Ghosts of dead hopes, half memories and half dreams haunted me."

We haven't even gotten to the good part yet. They were siblings, all three of them. Trust and Fordan were twins, born in that almshouse in Cornwall before being sent to far-flung points on the globe—she to Martinique and he to Alexandria. Then there's their brother Wroe, who ended up learning animal magnetism from the Indian Brahmans in Calcutta. They all ended up here in Alexandria at the old St. Paul's Cemetery—she in the grave while Trust confronts Wroe.

"Dead or living I fear you not, John Trust," Wroe exclaims in the St. Paul's Cemetery.

"I knew he did fear me," our narrator explains. "And that he believed he saw a specter, for his voice was choked and tremulous, and the arm he raised, as though to threaten, shook like an aspen."

Ultimately, the narrative of John Trust is a love story with some occult black magic and incest thrown in for good measure. It's a literary tale that unfolds

slowly, with key details missing until later in the narrative. And it's written in the flowery high Victorian style that offers an important window into the world of the Female Stranger. Here was a woman of her age, beautiful and damned. The stigma of incest, the shame she wanted so desperately to hide, was such an unspeakable social crime that it was better to remain a Female Stranger forever than for Blanche Fordan to wear a scarlet letter the rest of her life.

"It was hoped that the secret would be buried with her," concluded the narrative of John Trust.

Is she the Female Stranger? Or is it someone else, perhaps this criminal known as Clermont? Nobody really knows the answer. That's why these questions will linger forever at St. Paul's Cemetery and Gadsby's Tavern.

CHAPTER 3

FATAL AND MELANCHOLY AFFAIR

YOUNG LOVERS MEET A TRAGIC FATE

In many ways, this is a story about love. Boy meets girl. They fall in love and become inseparable. According to a newspaper account, he "had been her constant companion for years…she refusing to have any other company." Yes, this is a love story. But it ends in tragedy.

A vivid June 29, 1868 newspaper story in the *Alexandria Gazette* has long tugged at the imagination of those who walk into 107 North Fairfax Street, an unassuming three-story building off Market Square built in 1800. In the stilted Victorian prose of that era, the newspaper reported the shocking details of a romance in which young lovers die in a heartbreaking series of events. It appeared under the headline "Fatal and Melancholy Affair."

"This truly melancholy affair was the subject of general conversation yesterday and today," the *Gazette* reported the Monday afternoon following the tragedy. "Feeling allusions were made to it yesterday in some of the churches."

Since its first appearance in the summer of 1868, the article has taken on a life of its own—making the Fairfax Street building an Old Town landmark. It's a regular stop on the ghost tours that sweep through Old Town, and the candy store now located on the ground floor has become the gathering place for those who want to know more about the sad story. In 2004, the haunted house was featured on a cable television show on the Travel Channel called *Weird Travels*.

"It was creepy being in the house, knowing the history," said Jamie Duffy, who played the part of the leading lady in the cable television feature. "You wanted to do a good job because you didn't want something to happen."

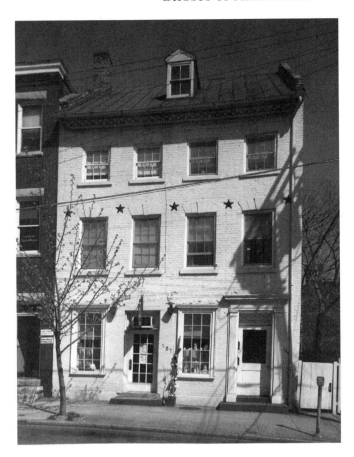

An 1868 newspaper article about tragedy at the Schafer House has long tugged at the heartstrings. *Alexandria Library Local History Special Collections.*

To set the scene, it's important to note that this was a time when Alexandria was still recovering from years of military occupation. The Southern economy had been decimated by the Civil War, and the city was stumbling its way through its new reality as a blind man might make his way through an unfamiliar alley—randomly groping into the abyss hoping to find something significant. The escape of young love certainly would have seemed like a welcome reprieve during this dark period of Reconstruction.

The spring and summer of 1868 were full of political tension. Headlines in all of the papers were dominated by the impeachment and eventual acquittal of President Andrew Johnson. Republicans gathered in Chicago that spring to nominate conquering Union General Ulysses Grant. And Democrats held their convention in New York City in the humid summer days to select former New York Governor Horatio Seymour. After being

under military occupation since the end of the war, the last remaining states were readmitted into the Union (except Texas, which had to wait until 1870).

This is the scene for our love story, set in a city that could certainly still be described as "war-torn." The *Alexandria Gazette* of the era carried stories reporting a bandit stealing postal deliveries and detailing the activities of a roaming gang of horse thieves. Violence was commonplace, and "disturbances" were frequently reported in the local news columns. Essentially, this was a time when loyalties were being tested and boundaries were being broken. Again, it was an ideal time to turn away from the garish light of day and toward the intoxicating concerns of love.

The leading man of this story is Charles Tennesson, described in the *Gazette* as "a young gentleman well and favorably known in the community." Census records show that his father, Samuel Tennesson, was a native of Maryland and worked in one of Alexandria's restaurants and that the Tennesson family had a considerable estate. Charles Tennesson's military record lists him as a clerk in Alexandria before enlisting in the Company Rifles of Virginia's Seventeenth Infantry Regiment—fulfilling the expectation of service for someone who was nineteen years old when Virginia seceded from the Union.

The *femme fatale* of the story is Laura Schafer, "the youngest and a beautiful daughter of Mr. Christian Schafer, the well-known and highly respected confectioner of Fairfax Street." Christian and Susan Schafer were emigrants from Germany who came to America and opened a confectionery in Alexandria. Census records show they immigrated before 1835 and that the shop was operational by 1850. The Schafers had a large family, with six children.

It was sweet romance for Laura Schafer and Charles Tennesson. And their romance must have made a scene, because the newspaper reported that it sparked rumors around town of an engagement between the two. But there would be no wedding for this young couple. The tragic events of a humid June evening began innocently enough, with twenty-six-year-old Laura Schafer dressing for the evening in her third-floor bedroom. She was accompanied by her eighty-six-year-old grandmother, Mary Ballenger. After "completing her toilet," she grabbed a kerosene oil lamp in one hand and headed toward her father's room, an adjoining space where she kept a drawer of handkerchiefs in her father's large bureau.

"She had hardly reached the center of her father's room before she heard the lamp crack, and was instantly aware that she was covered with the burning fluid," the *Gazette* reported. "She immediately threw the lamp from her to the hearth, and ran downstairs, screaming piteously for help."

William Phillips, the husband of Laura Schafer's sister, was sitting on the front steps outside the front door when her heard her desperate cries for help. Phillips rushed into the house on North Fairfax Street and saw her rapidly descending the stairs, "enveloped in flames that extended far above her head." Other members of the Schafer household were "startled by her cries" and rushed to the scene.

Young Laura turned to Phillips and "beseechingly implored him to save her." The heroic brother-in-law threw off his coat and wrapped it around her. Upstairs, the grandmother used a blanket to extinguish the lingering conflagration in Mr. Schafer's room. Soon enough, the flames were subdued. But it was too late. The fire had "accomplished its hideous work."

As the newspaper noted, the tragedy could have been avoided. In her fright, Laura Schafer flew down the stairs in such a hurry that the rushing air fanned the flames, consuming her. Had she remained upstairs, her grandmother could have thrown that blanket around her and saved her from the severity of the burns she suffered that evening. But that did not happen.

Instead, young Laura Schafer found herself on what would become her deathbed. The family sent for a man the newspaper referred to simply as Dr. Lewis. He arrived in short order and attempted "every expedient that science could suggest or art apply." Certainly, Laura was in agony as the night wore on and the dawn intruded the next morning. Nearly the whole surface of Laura's body had been severely burned, in some places to a crisp. Charles Tennesson was at her bedside when she drew her final breath.

"On the following morning, shortly after eleven o'clock," the *Gazette* reported, "she was relieved of her sufferings."

Her family was obviously devastated. But Charles Tennesson was ruined. The *Gazette* reported that three hours after Laura Schafer's death the twenty-six-year-old Confederate veteran sent for a friend by the name of Henry Green. A native of New Jersey, Green was a twenty-seven-year-old liquor dealer in Alexandria. He arrived at the Tennesson house, and the two friends set out toward the Schafer home. They walked down Cameron Street and turned right at Water Street and then turned right into Ramsay Alley leading up toward the Schafers.

But the friends never made it there. While they were walking through the alley, the two friends proceeded as far as the gate leading into the wholesale liquor store of Downham and Green—the business owned by the man from New Jersey. When they reached the gate, Tennesson stopped and proposed that the two go inside for a drink. Green didn't have a key to the back door with him, so he excused himself for a moment and entered through the front door on King Street.

Ramsay Alley was where a distraught Charles Tennesson became suicidal. *Alexandria Library Local History Special Collections.*

Inside the wholesale liquor store on a Sunday afternoon, only three hours after the death of Laura Schafer, Green supplied his grieving friend with a glass of liquor. The two were standing in the middle of the store when Charles Tennesson raised his tumbler and offered a toast. "Here's to you and I," announced Tennesson before downing the alcohol. "God save us."

Green took the empty tumbler toward the water stand. While his back was turned, Tennesson produced a five-barreled Whitney revolver from his pocket. With his right hand, he placed its muzzle to his right temple and pulled the trigger. The ball entered his skull and lodged itself on the other side. Green called for a doctor, and surgery was attempted to save Tennesson. But he was "beyond the reach of the assistance to be afforded by the earthly doctors." Tennesson was taken home, where his condition grew steadily worse. He never regained consciousness, and he eventually died on Monday afternoon.

"The parents of the young couple receive the sympathy of the entire community," the *Gazette* reported.

The double tragedy was a blow to Alexandria—especially to the young generation, many of whom counted the young lovers as friends. One such

friend named James Wood arrived at the Tennesson house to visit his dying friend in the hours before his death. After looking at Tennesson's body, laid out on the floor, Wood left the house and fainted on the street. After Wood fell on the pavement, rumors began swirling around town that yet another catastrophe had happened. But the city was spared a third death that day.

"He, however, after the lapse of an hour, and the administration of proper restoratives, recovered," the newspaper explained.

Since that summer, nothing has ever been the same at the Schafer House. Over the years, it's been a real estate agency and a Christmas trinket store. It's currently a candy store, a sweet turn of events considering the candy-coated tragic romance that happened here. And all of the people who have worked in and around the building have known that something is different about this house. Ghost tour guides who tell the story of Laura Schafer say that some strange things have happened. One of those who has experienced an out-of-the-ordinary encounter at the Schafer House is expert guide Marianne Meyers.

When Meyers first became a tour guide, the Schafer House was a holiday tchotchke shop known as the Christmas Attic. Emboldened by her new role as interpreter of Alexandria's history, Meyers went into the Christmas Attic to look around. She roamed freely through the building, exploring the upper floors and even taking a stroll through the basement—taking in the historic ambiance and getting a feel for what the house must have been like when the Schafers lived there.

When she got to the second floor, she was confronted by several big artificial Christmas trees taking up a lot of space in the narrow townhouse. And there were hundreds or ornaments of every description, crowding every inch of the second floor. The smell of potpourri was staggering.

"It was a bit overwhelming up there, and I found myself feeling very faint," said Meyers. "Was it the fun-house effect—too much potpourri, too much Christmas? I felt like I *had* to get out of there and I almost ran out of the room. I even broke out into a sweat."

Meyers said that she remembers this event so vividly today because of the strange feeling that washed over her when it was happening. It was like tidal wave of emotions. She said she had to leave right at that moment or something terrible would happen. The next day, she approached one of the Christmas Attic employees only to learn that strange things happened there every day.

"They told me that they had put up a new display, and when they came in the next morning, parts had been knocked down, not the whole thing," said Meyers. "Obviously Laura didn't care for it."

So was Meyers experiencing the ghost of Laura Schafer or too much potpourri? It's true that floorboards in the house are not quite level, contributing to the fun house effect. And there were certainly an abundance of olfactory sensations. Yet Meyers says that she was gripped by something she had never felt before—a feeling that came over her quite suddenly that she needed to get out of the building immediately.

"I keep an open mind about ghosts; one hears lots of stories as a ghost tour," she said. "But it was an odd experience."

The experience didn't stop Meyers from returning to the Schafer House, most of the time telling the story of Laura Schafer from outside the building on North Fairfax Street. On Halloween, she leads tours inside the haunted building. She's never had the same kind of experience since that day. Yet she still gets a certain feeling when she's near the house, a sense of unfulfilled longing that seems to be somehow a part of the house. While the candy store is buzzing with activity and life, the rest of the building seems to have a silent, watchful quality.

"Something I've noticed about buildings purportedly haunted is that they all have a sadness about them," said Meyers. "Something about the light in the rooms, I always feel longing in there, a sense of something unfulfilled.

The 100 block of North Fairfax Street features the Schafer House, which is second from the right, and the haunted Braddock House Hotel in the distance. *Alexandria Library Local History Special Collections.*

Personally, I've never seen a ghost but I know people who have, and they aren't ridiculous about it. Just a fact in their lives."

Enter Candida Kreb, who had never heard this story. She knew nothing about Laura Schafer or Charles Tennesson when she decided to open Candi's Candies at 107 North Fairfax Street in 2007. She had no clue that her six-year dream of opening a candy shop in Old Town would land her in the same building where Christian Schafer once sold treats as a confectionery—the same building where Laura Schafer once fell screaming down the same flight of steps that now greet Candi's customers.

It wasn't until a group of people gathered outside her building one day that she heard a ghost tour guide relate the tragic tale of Laura Schafer and Charles Tennesson.

"I don't believe in ghosts," said Kreb as she peered out the window to see a tour group stopped outside her candy store. "I guess you could say I'm neutral."

About three months after opening the shop, Kreb was working alone when she smelled something burning faintly in the distance. She ran out into the hallway to discover that she was alone in the building. She followed the smell upstairs, but nothing was on fire. She thought that it must have been a fluke or a neighbor smoking a cigarette. So she went on about her business as though nothing had happened.

But then, the very next day, the smell once again returned to the Schafer House—that distant sensation that something was burning. Once again, she checked various parts of the candy store to make sure that nothing was on fire. She walked into the stairwell where Laura Schafer died all those years ago. Nothing. Suddenly, it hit her.

"It was like one of those things when it all comes together at once," said Kreb, an immigrant from Honduras who came to America in 1980. "Something just sort of clicked, and I remembered the story of Laura Schafer."

But that's not the only strange thing that's happened to Candida Kreb at the Schafer House. One night, she was alone in the building after closing time. It had been a long day, and she was tired. Yet she was cleaning up the store and getting it ready for the next day. Kreb was halfway through her chores for the evening when she heard a voice in her head.

"Enough," said the voice. "Leave."

It wasn't the kind of voice she heard with her ears. Kreb described it as more like a voice she could feel without hearing. Frightened by the

experience, she stopped what she was doing and grabbed the cash out of the register—heading for the exit before she even had a chance to count it.

And then there's the basement. About a year after opening the business, she found herself alone in the basement of the haunted Schafer House. Unexpectedly, she stopped dead in her tracks—unable to move. She felt the unmistakable presence that she was not alone. And although she could not see who—or what—was haunting the basement, she somehow knew that it was a male.

"This was not Laura," said Kreb. "This was definitely a male. I could feel him there with me. It was spooky."

Kreb says her whole body erupted in goose bumps, from her head to her toes. She was frozen in her tracks for a few moments, not knowing whether she should stay or go. Eventually, she decided that she needed to leave as soon as possible. So she took off running. A few days later, she ran into a former employee of the Christmas Attic. She said she had also experienced the same unexplainable phenomenon in the basement but that she felt the ghost was just being territorial about his space and that he probably would cause no harm.

"She confirmed what I felt in the basement," said Kreb. "There's got to be something in the basement. There's no reason for me to feel the way I felt in the basement."

Perhaps this is the ghost of Charles Tennesson, haunting the building of his tragic love. Or perhaps it is some other ghost that haunts the house. In any event, the story of what happened to Laura Schafer is one of the most famous ghost stories in Alexandria, maybe because it has all the elements of a classic tale: love, loss, tragedy and redemption. Or then again, maybe it's because the story remains alive today because strange things keep happening at the Schafer House.

Today, Kreb keeps a receipt in a special place behind the counter. It's not the first sale she ever made or the biggest dollar amount sold at once. It's a ticket signed by a woman named Laura Schafer. Kreb says that she keeps it around to remind her of the tragic story that unfolded here many years ago, at a candy shop run by an immigrant from a different era.

"It's a sad story," she said after a customer purchased a handful of saltwater taffy. "I guess you could say it's a little like Romeo and Juliet."

THREE FALLING GHOSTS

PHANTOM HOTEL HAUNTS THE CARLYLE HOUSE

The Carlyle House may be one of the most recognizable buildings in Old Town. Yet there's an almost unrecognizable presence lurking in that front lawn, behind the red brick wall along North Fairfax Street. This was the site of Green's Mansion House, later known as the Braddock House Hotel.

Don't look for it today; it's not there. But the phantom building remains a haunting part of the streetscape on North Fairfax Street, located directly across from City Hall. Here is where a grand hotel once dominated the block, confiscated by Union soldiers and converted into a hospital where at least one soldier would fall to his death. The hotel later became a slum where others would fall to their deaths.

Don't look down. Not now. This place is haunted.

This is not a story about a haunted building. It's a story about a haunted spot where the haunted building once stood. The story begins in 1840, when a wealthy furniture manufacturer purchased one of the oldest houses in Old Town. Known as the Carlyle House, the old abandoned house was but a shell of its former self. The colonial splendor had long since faded, and the promise of the early republic had vanished as the nineteenth century matured into its middling years.

Enter James Green, one of the city's leading men of commerce and Alexandria's premier furniture manufacturer. His factory was located a few blocks away on South Fairfax Street. In April 1848, he expanded entrepreneurial enterprises to include hospitality. That was the year that

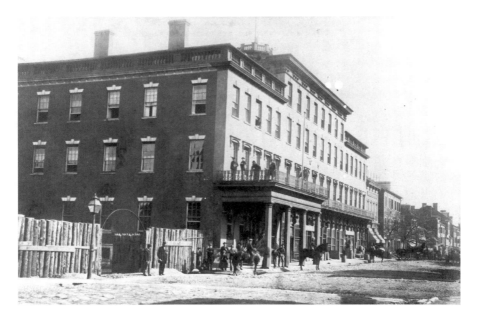

Green's Mansion House served as a hospital during the Civil War. *Alexandria Library Local History Special Collections.*

Green acquired the old and abandoned Carlyle House for $3,000. The nearby Bank of Alexandria, which he had already purchased, was converted into a hotel he called the Mansion House. People took to calling the operation Green's Mansion House.

At first, business was booming. Guests were arriving with such regularity that Green was able to finance a major expansion. By 1855, he was already hard at work constructing a large four-story addition along the entire open space along Fairfax Street. It was destined to become haunted. But that was later. This was a time of promise.

Guests at the hotel were invited to enter a courtyard between the hotel and the spooky old house, a relic of a bygone era that was rapidly becoming a fading memory of an earlier generation. Today we call this era "antebellum." But that's unfair to the people who lived at that time, blissfully unaware that the storm clouds were approaching. When Union forces invaded Alexandria and occupied the city, the army marched into town and laid claim to Green's Mansion House. According to one account, army leaders offered Green rent if he would take an oath of allegiance.

Green never pledged allegiance, and his property was confiscated by the Union.

"The first floor of Green's factory on South Fairfax Street, which is now a parking garage, was used as a prison for Confederate soldiers," said ghost historian Wellington Watts. "And they converted his hotel to a hospital."

Green's Mansion House was not the only building in town that was converted into a hospital. There were many homes, churches and public buildings that were converted to this purpose. Such was the burden of being a Virginia city under Union occupation at the end of a rail line. Yet unlike the other hospital buildings in Alexandria, this was the largest. Hundreds of soldiers convalesced here, and doubtlessly many died here. The facilities included five hundred beds and a dumbwaiter capable of transporting medical supplies, food and even patients. Patients rarely got enough to eat at Green's Mansion House Hospital, where the nurses accused the hospital stewards and cooks of hoarding.

The food was notoriously bad. According to one nurse, the bean soup and beef tea were always salty. The *Alexandria Gazette* described the bread as "unusually sour" and the coffee as "trash unfit to drench the meanest brute." Perhaps this was the perfect storm for making soldiers, torn by the horrors of war, lose their minds.

"The Battle of Fredericksburg had so much carnage that the hotel overflowed with carnage," explained Watts. "It was so bad they had to line the bodies up along Fairfax Street and into Market Square, and many of the soldiers died of exposure to the cold."

One of the Union soldiers apparently wasn't able to take the strain of living among so much death. According to city historian Michael Miller, the soldier went insane and managed to get through a window in his ward. He escaped out onto the eaves of the building, hanging there for a short time before finally falling to the balustrade of the hotel below and becoming so seriously inured that he died a few hours later. The way ghost tour guide Ken Balbuena tells the story, his crazed imagination had persuaded him that the Confederates were out to get him.

"He thought the Rebels were on the march," explains Balbuena. "So he was trying to make an escape when he fell to his death."

After the war, Green returned to business. The southern economy would never return to its previous self. But Green seemed to be able to keep his head above water, maintaining his furniture business and his hotel. He died in 1880, and the business was renamed Braddock House Hotel, a reference to the famous British general that once planned his fatally ill-conceived war plans against the French here.

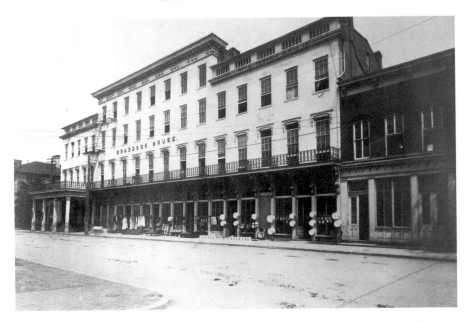

After the death of James Green, the hotel became known as the Braddock House. *Alexandria Library Local History Special Collections.*

One summer day in 1905, a fifty-year-old cabinetmaker by the name of Samuel Markell was at the Braddock House when tragedy struck. Census records show that Markell's father, who was also named Samuel Markell, was a wood-turner. Perhaps they had been old family friends with the Greens. Or perhaps the younger Markell had arrived here looking for trouble. Whatever the reason Markell was at the Mansion House that day, it wouldn't end well. According to an account published in the *Alexandria Gazette*, Markell fell fifteen feet from an upper-story platform and was killed instantly. The newspaper reported that he struck his head and broke his neck.

"Late in the evening he was seen by certain inmates of the Braddock House lying in the court," the *Gazette* reported. "And they, supposing he was asleep, made no mention of the matter."

The next morning, though, he was found dead. The officer who responded to the scene conducted an investigation and concluded that Markell had been dead for about twelve hours. He surmised that Markell must have been sitting on the railing of a platform or bridge leading from the Carlyle House to the hotel. Although rumors emerged that Markell might have been robbed of his watch and thrown off the platform, Chief Webster later

announced that the timepiece had been found. Markell's body was taken to Demain's funeral home. He was eventually buried in the family plot at Methodist Protestant Cemetery, where wild strawberries now bloom over his grave each spring.

By the time the third weird happening took place at the Carlyle House, the hotel must have fallen into a state of disrepair, because the newspaper referred to it as "the old rookery," a nineteenth-century euphemism for slum housing. For reasons unknown, it became the final destination for one Patrick Buckley, the handsome and irascible twenty-year-old known as Alexandria's "boy guide."

Buckley first came to prominence at age thirteen. But he had competition. Lots of it. This was a time when the city's streets were overrun by young boys who met arriving trains and boats to offer historic tours of Alexandria. The volume of tour guides and the opportunity for fraud was a concern to members of the City Council, who eventually mandated that tour guides take out a license and pay an annual fee of five dollars. According to the *Alexandria Gazette*, Buckley "was the only one who had sufficient nerve to apply for the license." The 1910 census listed his occupation as "guide."

One of Buckley's tours would have likely hit all of the relevant points in Alexandria's history, starting with an introduction to John Carlyle—an ironic twist of fate considering Buckley's fall from grace. Carlyle was a Scottish businessman who arrived in Virginia at the age of twenty-one ready to make a new life for himself. Carlyle did what many aspiring young men from this era did: he married up—acquiring a Fairfax wife and Fairfax money.

It's likely that Buckley would have taken his tour of out-of-towners to the intersection of Fairfax and Cameron Streets to explain the importance of Thomas, the baron of Cameron and the sixth Lord Fairfax. He probably would have explained how the first lots were sold at auction in 1749 and that one of the original purchasers was Lawrence Washington—older half-brother and mentor to young George Washington.

If Halloween were approaching, Buckley might have carefully selected some gory details to weave into the narrative. There's the War of Jenkins' Ear, for example—an armed conflict launched when an English captain named Robert Jenkins had his ear severed by a Spanish commander. After Jenkins produced the ear during a particularly shocking session of Parliament, war broke out with Spain, and Lawrence Washington gained fame in the British navy serving under Admiral Edward Vernon. For a laugh, Buckley might have explained how Lawrence Washington named his house after his boss—the ultimate form of sucking up.

The Carlyle House was hidden from view on Fairfax Street by the hotel, the large building in the background with the cupola on top. *Alexandria Library Local History Special Collections.*

Then there's the gruesome tale of Monongahela, the remote conflict in the wilderness of an area then known as the Ohio country. Essentially, the story involves Washington and a Catawba Indian ally known as Half King getting into a scrape with a French officer by the name of Joseph Coulon de Jumonville. Washington and Half King orchestrated an ambush of the French forces. Then, just as Jumonville was trying to surrender, Half King sank his hatchet into Jumonville's head with such force that he split the Frenchman's skull in half. Then he reached into Jumonville's head, pulled out his brain and washed his hands in the mixture of blood and tissue. The other Indian warriors immediately began scalping the other French soldiers. One was decapitated, and his head was put on a stake.

Ultimately, the highlight of the tour was bound to be the Carlyle House. This is where John Carlyle played host to British General Edward Braddock. After the massacre at Monongahela sparked a world war, Braddock decided to launch the invasion from Alexandria and plotted strategy with the other

colonial governors in Carlyle's dining room. Unfortunately, the general died in battle, and his corpse was buried in the middle of the road used by the British for retreat to prevent the Indians from desecrating his body. This is when a young lieutenant colonel by the name of George Washington rose to prominence by leading the retreat.

These stories and others were certainly part of Buckley's extensive repertoire. Unfortunately for the boy guide, his story would have an ending just as gruesome of the city's darker tales. One autumn evening, shortly after the election of Woodrow Wilson as president, Buckley and his brothers enjoyed a raucous night out on the town. The twenty-year-old guide and his brothers were apparently kicked out of several bars along King Street, carousing until the early morning hours. When the proprietor of one barroom tried to throw him out, Buckley became disorderly and got into a scuffle—one that left his coat torn and his face cut.

Shortly after midnight, the men entered a Greek restaurant on King Street, where they got into another fight and were yet again shown the door. That's when the brothers parted ways, and Pat Buckley headed toward the Braddock House Hotel. He entered from the Cameron Street entrance and stumbled to a window at the end of a hall on the fourth floor. He removed his long overcoat and hat, placing them on the floor, and walked out onto the iron fire escape.

"W.W. Simpson, proprietor of the Braddock House, heard Buckley enter the building and yelled to him to stop making so much noise," the *Gazette* reported on November 18, 1912. "He did not know who it was at the time and said yesterday morning if he had known it was Buckley, he would have stopped him from entering the building."

Apparently, Simpson had already ordered Buckley never to return to the Braddock House at night. The reason was apparently the young man's attention to his daughter. Perhaps it would have been better for everyone if Simpson had thrown Buckley out, which would have been the third time that evening. But that's not what happened. Instead, the twenty-year-old tour guide extraordinaire fell to his death—just like the insane Union soldier and Samuel Markell.

His body was discovered at 6:50 a.m. the next morning by a roomer at the building, who alerted the hotel management. Considering that the police department was located across the street, it wasn't long before officers were on the scene investigating. They found Buckley lying on his back with his skull crushed and his face cut in several places. His coat was covered in blood, which also ran from his nose to his ears. His coat collar was torn,

and the officers initially thought that might have indicated some kind of struggle leading to his death. So the first report was that he was murdered and thrown from a window.

First reports can often be wrong, as was apparently the case here. The chief of police entered the picture and personally led the subsequent investigation. Together with the prosecutor and coroner, the city leaders would eventually conclude that Buckley fell from the fourth-story and that his fall was an accident. The coroner issued a certificate of accidental death and suggested that further inquiry into the death was not warranted.

But was it really an accident? Was it mere coincidence that the Union solider and Samuel Markell and Pat Buckley all *accidentally* fell to their deaths at the Braddock House Hotel? Or was something else at work here? In 1989, city historian Michael Miller suggested that there might be more to the story.

"On Halloween night this year, stalk to the old Carlyle House and peer across the brick wall as the moonlight illuminates the old edifice," he wrote. "If you look carefully, perhaps you may see three fleeting lights in the yard as the spirits of the insane solider, Markell and young Buckley return to the scene of their tragic deaths."

Today the Carlyle House remains free of ghosts, although the same cannot be said for the surrounding lawn. Perhaps this was because someone saw to it that a dead cat was interred in the basement wall near the chimney in a crouched position. According to the spiritual thinking prevalent in the Scotland of Carlyle's day, a cat in this position can scare away evil spirits. The presence of the cat was unknown when the Northern Virginia Park Authority acquired the property in the 1970s and began an extensive renovation.

"Nobody knew about the cat until they were shoring up the foundation, and it was quite a surprise," explained Jim Bartlinski, director of the Carlyle House Museum. "Maybe it worked to ward off ghosts. But it sure didn't bring John Carlyle much luck."

Carlyle lost nine of eleven children. But at least the evil spirits stayed away—although perhaps not from the front lawn that now separates the house from North Fairfax Street. Many people say the lawn is haunted by the three falling ghosts—the insane Union soldier, Samuel Markell and Pat Buckley. Alexandria Colonial Tours owner Wellington Watts says that he often heard from visitors who say that strange things appear in photographs of the front lawn of the Carlyle House, home of the three ghosts and former location of the Braddock House Hotel.

"We've had customers on our tour come back after the tour and say they've seen orbs or ghosts in photographs," said Watts. "Clearly, there's a ghost or two or more still walking those grounds."

For two of Old Town's ghost tour guides, this is more than a matter of passing interest or academic scholarship. It's a personal story of ghosts reaching out from beyond and grabbing tour guides as they lead groups through the city streets. The first guide to become victim was Kelsey Whitlock. In October 2008, she led a group onto the lawn to tell the story about how the three men had fallen from the old hotel and how they now haunted the spot where they died.

"As the group was gathering, I felt this tug about waist-high on my dress. I thought it was one of the kids so I turned around. But there was nobody there," explained Whitlock. "It did send some chills down my spine."

That same night, one of the tourists took a photo in which three blue orbs appeared in the front yard. That was spooky. But what was even spookier is what happened to ghost tour guide Ken Balbuena a few weeks later. He had assembled his group in the front lawn of the Carlyle House and was explaining the story of the three falling ghosts. Then he told the story of how John Carlyle's old cat has been protecting the house from evil spirits for hundreds of years. Finally, the story came to a dramatic conclusion.

"I can pretty much guarantee you that if you go into the house, nothing bad will happen to you," Balbuena told his crowd that chilly October evening in 2008. "But I cannot guarantee you the same safety while you are standing on the grounds of the Carlyle House."

That was how Balbuena usually ended the story of the three falling ghosts. But this would not be a routine night. Just as he said that last line, he felt a hand on his left shoulder. He thought it might be one of the chaperones, so he turned around to see whether someone in the group was having an emergency. But there was nobody there. Balbuena quickly ended the tour and moved on to the next stop.

"It was almost like the experience you get on a roller coaster. I could feel it at the pit of my stomach," said Balbuena. "I was genuinely scared for the first time."

Balbuena's tour now has a new ending. He explains the story of the three ghosts and Carlyle's cat. But he also adds what happened to Kelsey Whitlock and himself.

"I keep waiting for the hand to come back," he said. "Perhaps it will touch my other shoulder this time."

CHAPTER 5

WAR OF THE ROSE GARDENS

DISAGREEMENT LINGERS ON FRANKLIN STREET

W ho owns the past? That's a question of lingering disagreement at 414
Franklin Street in a part of Old Town known as Yates Gardens. Some
say that the house in the middle of the block is an old tavern where George
Washington celebrated Independence Day in 1798. Others say that the
former president was several blocks away at a tavern next to a graveyard.
Lingering over the war of words is the ghost of a Revolutionary War soldier
eager to show the way.

From the curb, the house might not seem all that remarkable. Set back from
the street and guarded by a white picket fence, the red brick house strikes a
colonial note in a neighborhood dominated by buildings that replicated its
features in later generations. Gardens bloom in the spring as songbirds sing
through the early morning hours and the salvia creeps through the mulch
and clay. But that's a front. Inside there's something else creeping through
the night. This place is haunted.

The ghost of a colonial soldier has been seen lurking around inside the
house and out back. It's possible that the ghost of the Continental is coming
back to an old haunt, a tavern where he once enjoyed rest and relaxation.
Then again, it's possible that the ghost is trying to tell us something, lead us
to discover the answer to a lingering mystery. Perhaps it has declared victory
in the battle of Yates Gardens.

Enter Ruth Lincoln Kaye. She's researched more than 260 houses in
Old Town, cornering the market for copyrighted private research about
individual homes. Her 1920s-era home behind the Masonic Temple

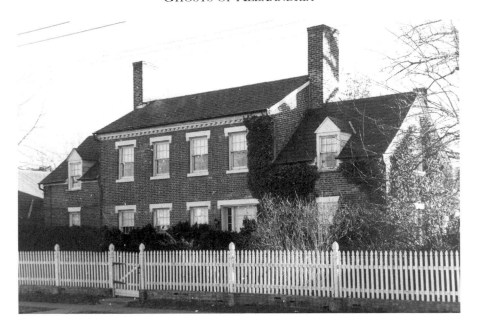

The house at 414 Franklin Street is one of the oldest buildings in the Yates Gardens neighborhood. *Alexandria Library Local History Special Collections.*

is crammed with countless volumes of private histories, decades of careful research and investigation. One of the carefully documented and copyrighted reports is her work about 414 Franklin Street commissioned by Richard and Susan Dowell.

The Dowells knew that the joint was haunted, right down to its wooden rafters. The rambling series of buildings and additions had strange proportions, oddly shaped rooms, a bar along one of the downstairs walls, creaky old floors and a musty basement. It was a warren of hallways and passages leading to strange twists and turns. Every now and then, they would hear the distinct sound of footsteps on the long, wide pine floorboards. Richard Dowell told a newspaper reporter from the *Alexandria Journal* that a chandelier once fell in the dining room.

"And you can make what you will of that," the homeowner is quoted in the newspaper.

Essentially, the Dowells were saying that the house was more than bricks and mortar. It was also the home of a ghost—the same colonial soldier known to have haunted the house for many years. One day, Sandra Dowell was working in the garden when she overturned some sod that she said

"abounded in the pungent odors from a barnyard...or a livery stable." Even the backyard seemed to be holding fast to a long-forgotten past, gripping the property with a sense that the past isn't over. It's not even past.

"In the house, you don't feel alone," Richard Dowell was quoted in the *Journal*.

Like many other families, the Dowells wanted a swimming pool in the backyard. This was in the 1980s, and it was the trendy thing to do. It would increase the value of the house, and it would create a soothing water feature in the well-manicured Yates Gardens neighborhood. But they couldn't just hire contractors and start the project. This is Alexandria, where excavations can turn up everything from a prehistoric shaved rock to a fully clothed Revolutionary War soldier, identity unknown. According to the city's 1989 archaeology ordinance, the Dowells had to wait for the archaeologists to do their thing.

That's when the trouble started. Archaeologists began digging in 1985. The Dowells had to pay private contractors to do the work, which was overseen by city archaeologist Pamela Cressey. Her investigation led to some shocking findings that challenged the association between Washington and the haunted house. But that came later. At the beginning, everybody was singing from the same hymnal—one that had been documented in books, articles and house histories.

"We assumed that 414 Franklin Street was Spring Gardens Tavern where George Washington attended the famous July 4, 1798 celebration of the Anniversary of Independence," Cressey wrote. "Therefore, we expected that the archaeological evidence could reflect such celebration, as well as general tavern and garden activities."

But that's not what she found. Instead, the evidence led Cressey down an entirely different garden path, one that raised a number of questions about the history of 414 Franklin Street. For starters, the building may have never been a tavern at all. After combing through tax records, narrative descriptions and contemporaneous accounts, Cressey concluded that the property was once known as Peter Billy's Pleasure Garden, later known as Yates Gardens.

Meanwhile, city historian Michael Miller unearthed documents revealing that a property sometimes known as the Spring Garden Farm tract adjoined Alexandria to the west. He pointed to a physical description of Spring Garden Farm from a Fairfax deed book. The old ledger said that "Spring Gardens" entered a gut running into Hunting Creek, yet another indication

The history of 414 Franklin Street is a matter of dispute.
Alexandria Library Local History Special Collections.

that the Spring Garden tavern was several blocks west of the 414 Franklin Street location.

Together, Cressey and Miller put together a case that the real Spring Gardens overlooked the city cemetery. The area was just outside the city limits, within sight of one of the boundary markers placed here in 1791 to designate the shape of the new District of Columbia. This was a time of great promise here on the banks of Hunting Creek. The pair of iconoclastic researchers said that this was the true location of Spring Gardens, where Abel Willis took out a 1786 advertisement in the newly formed *Alexandria Gazette*.

The *real* Spring Gardens, according to Cressey and Miller, was ten blocks northwest of the house at 414 Franklin Street. As evidence, Miller offered the 1786 advertisement. The message received by subscribers to the newly formed newspaper that was published at Printer's Alley left readers with the impression that Spring Gardens was outside the city limits.

"After much trouble and expense," wrote tavern keeper Abel Willis in the pages of the *Gazette*, the place has been "up and complemented the SPRING GARDENS, a moderate walk from Alexandria, convenient for the reception of ladies and gentlemen, where they will meeting with good attendance on the most reasonable terms and where tea and other entertainments are provided on the shortest of notice." Sounds like the kind of place where General Washington once partied. But where was Spring Gardens?

Miller says that it was located north of Payne Street between Wilkes and Wolfe Streets. And he had proof. Follow this closely. Here's how the location was described in a Fairfax County deed book:

> *Beginning at the intersection of Wolfe & Payne Lanes and running thence westwardly with Wolfe Lane to its intersection with Hamilton Lane, thence southerly with Hamilton Lane to its intersection with Wilkes Lane to its intersection with Payne Lane, thence northwardly with Payne Lane to the beginning a part of which ground was demised for a term of years by William T. Alexander unto Abel Willis, which term is not yet expired and the same by Willis assigned to Mandeville.*

Got that? There'll be a test later. For now, let's get back to Franklin Street—ten blocks south of the location where Cressey and Miller have now proclaimed to be the *true* location of Spring Gardens. Now a cloud of doubt was being cast over a very important subject. Was the Washington association with the Franklin Street house just a matter of neighborhood gossip? Perhaps the ghost will have something to say about the debate.

Let's look at the evidence presented by each side in this war of the rose gardens. The battle of Yates Gardens had two commanding generals. Renowned historian Ruth Lincoln Kaye is on one side, defending her home turf and the proposition that this house was indeed the location of Washington's 1789 visit. Marshalling the opposing army are city historian Michael Miller and city archaeologist Pamela Cressey. The two sides clashed bitterly.

"It was a knock-down drag-out fight," chuckled Miller.

"Mike and I never really got on after that," responded Kaye.

The bombshell revelation about the *true* location of Spring Gardens reshuffled the deck with which historical parlor games were played. It was a war waged across a terrain of essays and letters to the editor of the now defunct *Fireside Sentinel* in 1989. Even now, the dispute remains somewhat unsolved, although the ghost lurking around the house may have a clue as to its history. This is an important question because of the association that George Washington had with Spring Gardens—wherever it was.

According to Washington's diary, he visited a place called "Spring Gardens" for a Fourth of July celebration on a clear morning in the summer of 1798—just a year and a half before his death. The diary notion describes Spring Gardens as "a modest building surrounded by gardens set in the fields

south of Alexandria." Washington, who stepped down after two presidential terms in 1797, explained that Spring Gardens was "a popular setting for large gatherings."

Suddenly, Washington had been yanked ten blocks northwest. But then there's that ghost lingering about. Perhaps, says Kaye, that old Continental soldier lurking around the Franklin Street house might also be the same spook haunting the Swope House and a number of other locations around Old Town.

"That solider has been seen in many places, like the old Dr. Craik house," she said. "It doesn't have to be the same ghost, but it could have been."

Kaye thinks that the ghost of 414 Franklin Street just might just have the answer to the debate about Spring Gardens. He might even have circled the enemy and positioned himself for checkmate. When asked about evidence, she begins by producing a 1928 book written by local historian Mary Powell. In the book, titled *The History of Old Alexandria*, Powell includes the Franklin Street property in a section detailing old taverns. But Miller dismisses the Powell book as hokey folklore.

"Mary Powell is good for giving flavor to a lot of local history but it's not necessarily historically accurate," said Miller. "She created more misinformation than Carter has pills."

Okay. But what about Ethelyn Cox? Here was a trusted source, a careful researcher who lived in a haunted house on Prince Street. In her 1976 book, *Historic Alexandria Virginia Street by Street*, Cox explains that William Yates purchased the quarter-block property in 1818 and that today the house is in a neighborhood at Yates Gardens. The section on 414 Franklin Street includes the following notation: "Traditionally, 'Spring Gardens,' an early tavern where George Washington joined the celebration of the Fourth of July in 1798."

That first word struck Cressey as strange. "She is usually very precise about sources, dates, names and uses of buildings in her book," wrote Cressey in a December 1989 essay for the *Fireside Sentinel*. "Why did she cite no other evidence than tradition?"

In the 1989 essay, Cressey explained that twenty-five separate excavations at Franklin Street unearthed *no evidence* of an eighteenth-century tavern, celebrations or other daily tavern activities. In fact, Cressey explained, artifacts here occurred in far fewer number and smaller size than most Old Town archaeological sites. Using archaeological digs from other sites as a baseline, Cressey determined that the Franklin Street property didn't have the same number of creamware, pearlware or glassware that were found at other taverns in Alexandria.

So, she concluded that the Franklin Street property *couldn't* be Spring Gardens. It just didn't have enough small fragments of eighteenth-century ceramics throughout the backyard. That didn't mean that they were absent. The archaeological investigation of 414 did unearth some material. But Cressey determined that they were probably nineteenth-century deposits similar to residential backyards throughout Old Town. A large oyster shell deposit was discovered. But the professionally detached city archaeologist cautioned that this kind of finding is common throughout the residential areas.

"The significance of 414 Franklin Street transcends mere facts of who did what on that land," Cressey concluded. "Traditions and traditional places have meaning in our lives. This property represents one of the few laces in the entire city where I can still feel that past."

Kaye was not willing to let this tradition die. Why should she? Why should anybody, even the undead? Perhaps, just perhaps, says Kaye, the ghost of 414 Franklin Street has something to say about the dispute over the location of Spring Gardens. The theory rests on the most famous ghost story ever to happen at Yates Gardens. It's so well known that it's featured in a number of books and newspaper articles. It was even the subject of a painting by Alexandria artist Babs Van Swearingen.

The story begins with William Yates, who arrived on the scene in 1828—about thirty years after the disputed Fourth of July celebrations. A Quaker from England, Yates purchased the Franklin Street property between Pitt and Royal for $4,000 and launched a new business here.

Clearly, the Yates family got in on the ground floor of this opportunity, even if William Yates died shortly after cutting the deal. Later that year, his son took out an advertisement in the *Alexandria Gazette* that he would be open for business at the location, selling fruit trees bearing pears and "apples of all sorts." The Yates market garden would also be stocked with ornamental trees such as common locus and honey.

"Also, a handsome collection of Green House Plants and Shrubs, Garden Seeds, &c," the advertisement noted. "All which will be disposed of at reduced prices for cash."

Don't forget, this house is haunted. The most famous ghost story of 414 Franklin Street involves the Yates sisters, elderly women who lived in the house in the 1920s. By this time, the house had been in the family for a century. The story goes like this: The Yates sisters knew that there was something weird about this house. They could feel it. The persistent sense of a ghostly presence became an Old Town nightmare for the spinster sisters,

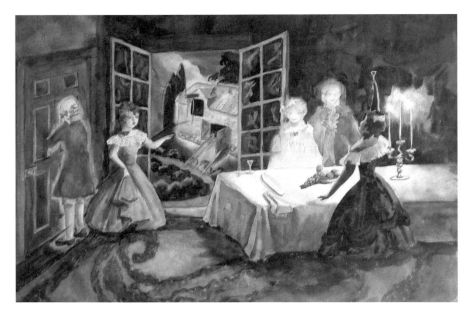

A 1950s-era painting by Babs Van Swearingen features ghosts hanging out at Spring Gardens. *Alexandria Lyceum.*

who became increasingly terrified of the many repeated hauntings. On several occasions, the sisters saw an "uninvited guest" wearing the uniform of a Revolutionary War soldier. One evening, they were eating dinner, and he appeared in the dining room.

"In the buff," explains ghost tour guide Barbara McAdams, pausing for effect. "And blue."

McAdams has told the story for years, passing along the traditional line that Washington ate here and that the house is, in fact, haunted. In her version of events, the Yates sisters were obviously surprised by the appearance of a colonial soldier so many years after the war. The apparition apparently walked right past the Yates sisters and through a sturdy paneled door. The sisters were amazed by this dumbfounding development. And so, summoning all the courage they had, the women followed the apparition out of the house and into the tavern. There, in the moonlight, the girls saw the specter enter a brick barn they had never seen before.

"It was shrouded in a greenish yellow mist," explains ghost tour guide Ann Dryden, who has also retold this story many times over the last two decades. "By that time, they did what any sensible people would do under those circumstances. They went to bed and covered their heads."

The next morning, the women were feeling much braver. So they returned to the spot where they had seen the mysterious building. The soldier was gone, and the brick barn they had seen the previous evening was gone, too. So the sisters scoured the area, looking for clues as to what may have happened the previous night. There, in the dirt, they found a brick outline of an old foundation. After some investigation, the Yates sisters found out about the history of the building as a tavern.

They discovered that an old brick barn had indeed once stood at that exact spot in the backyard. They began learning about the history of the house as a tavern. And they even came across references in old yellowed copies of the *Alexandria Gazette* that this tavern once hosted that famous Fourth of July party for George Washington.

Essentially, Kaye explains, it's possible that the ghost of the colonial soldier led the Yates sisters to the exact spot that would later become the site of a key archaeological finding. Sure, it wasn't the kind of deposits an archaeologist would expect to find at the site of an eighteenth-century tavern. But it was something. And if the archaeologists dug a little more, Kaye suspects, they would have found more evidence. Ultimately, she believes, this was enough evidence to prove that this was a tavern and therefore the location of Spring Gardens (and therefore the spot where Washington dined).

"There were an awful lot of oyster shells they found out back, and that's sort of what convinced me because that's what taverns offered in those days," said Kaye. "Pam thought that wasn't particularly interesting."

There was that downstairs room with the bar going cattycorner across a back wall, just as it should for a tavern of this time. And there are the tax records that indicate that the house was built long before William Yates arrived on the scene. As far as Kaye is concerned, the famous colonial ghost that has haunted the building and the Yates Gardens neighborhood for years led the Yates sisters to the trump card—the final blow in the battle of Yates Gardens.

"I'm pretty acute about ghosts," she explained. "And I think this house is definitely haunted."

Kaye points to a specific finding in the center of the back garden. This is where the archaeologists uncovered a series of post holes about three feet down near the southwest corner of the modern-day pool. The researches dated the post holes as being dug *before* 1780. In the post holes were clues to the eighteenth-century history of the area—German stoneware, English pearlware and a tiny piece of glass from the bottom of a wine bottle.

"That's probably where the Yates sisters saw the ghost," explained Kaye.

The value of an association with George Washington is difficult to calculate. But it's almost certain to increase the value of a home. After Ruth Lincoln Kaye documented the association that George Washington had with the house, it sold for $1.6 million in the autumn of 1989. As this book goes to press, the house is once again for sale, this time the asking price is $3.9 million. The listing announced that "this lovely home was originally a tavern in which George Washington spent his last Fourth of July!"

But wait. What about the ruling of the city historian and the city archaeologist in 1989, the last time the house was for sale? What about the board of architectural review documents from 2000 that specified that the property had been misidentified as Spring Gardens and probably had no association with George Washington? Those things seem to have been tossed out the window.

Ghost tour guide Anne Dryden has an explanation. In her version of events, the Dowells were digging in the garden one day when they uncovered some dirt and were overwhelmed by the stench of horse manure. Familiar with the story of the Yates sisters, they ran to get a neighbor to witness the pungent revelation. Just then, a brief storm swept through Old Town and washed the smell away. By the time when the couple returned to the site, the smell was gone.

"Well, I don't know about you," one neighbor said to the other, according to Dryden. "But this story smells less like horse and more like bull."

CHAPTER 6

LOST CAUSE

JAMES W. JACKSON AND THE WAR OF NORTHERN AGGRESSION

Victors don't always write history. Sometimes the vanquished have their say. Such is the case at the corner of Pitt and King Streets, where an old plaque beckons passersby with a headline boasting "The Marshall House." Those who stay to read the rest of the plaque experience a strong dose of Confederate patriotism honoring James William Jackson, adding that "the justice of history does not permit his name to be forgotten."

Clearly his name has not been forgotten.

People are still taking about James W. Jackson. Some even say that he haunts the building. He's considered by some to be "the first martyr in the cause of Southern independence," the subtitle to an 1862 biography published in Richmond the year after his death. Never mind that others consider Jackson to be a coldblooded killer responsible for the murder of Colonel Ephraim Elmer Ellsworth—at least for now, until we learn from the unvanquished plaque author that Jackson is "an example to all" who "laid down his life…in defense of his home and the sacred soil of his native state: Virginia."

"The plaque has a very Southern point of view in terms of protecting hearth and home," said city historian Michael Miller. "The concept of property rights was deeply ingrained in the Southern mentality."

Some say that he's still protecting the old Marshall House, with his shotgun at the ready against the invading Union army. Others say that this spot is haunted by the ghost of Ellsworth, still ready to take the enemy in the afterlife. Perhaps both of these men are still hanging around, shooting at each other in a lost cause. Guests at the hotel now located on that spot

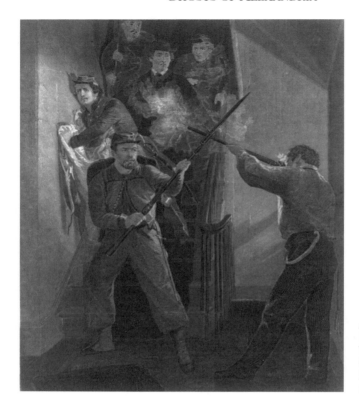

An illustration from 1861 shows James W. Jackson killing Colonel Elmer Ellsworth. *Library of Congress.*

have reported hearing some strange things, a phenomenon featured by the History Channel and enduring in local legend.

"People often say they hear the sound of gunfire," says ghost tour guide Ken Balbuena. "Others say they have seen Jackson and Ellsworth wandering through the building."

The plaque at the corner of Pitt and King Streets is a curiosity for people who are unfamiliar with the events that took place on May 24, 1861. Upon first reading, many plaque readers are left with more questions than answers. Why was Jackson defending his home? What's this business about the "sacred soil of his native state?" After the 400 block of King Street emerged from the scaffolding of a yearlong reconstruction effort in 2008, the questions proliferated.

"It definitely seems a little one-sided," said Nick Gregory, former manager of the Hotel Monaco. "People have very strong views about the plaque."

Since the old Holiday Inn was constructed in 1972, the plaque has been laying a Confederate spin on anyone who took the time to read its contents.

Those who ventured into the lobby discovered a framed portrait of Jackson hanging above a nineteenth-century photo of the Marshall House. When Kimpton Hotels bought the property and announced plans to open a Hotel Monaco, those two items were inherited along with the pro-Confederate plaque. Then, when the new hotel opened in 2008, Gregory said that many questions about how to interpret the history of his famous block had yet to be answered.

"It has to be done in a tasteful way," he said at the time. "And I still haven't figured out how to do that."

Interpreting the block of King Street is a difficult task, one that was of immediate concern in the wake of the urban renewal efforts that demolished three historic blocks of King Street during the 1960s and 1970s. Shortly after the Holiday Inn opened in 1972, the Alexandria Archaeology Commission installed an exhibit of abandoned household items found in the privy of former *Alexandria Gazette* editor Samuel Snowden. His house at 105 South Royal Street was razed to construct the massive hotel, which a board of architectural review report noted was designed to resemble the eighteenth-century warehouses flanking Faneuil Hall Marketplace. There in the lobby of the Holiday Inn, next to the portrait of Jackson and the photograph of the Marshall House, was a Chippendale-style cabinet containing pieces of Snowden's press, a clay pipe, a bone-tooth brush, a silver spoon and several wine glasses.

"Once you take these things out of the ground, nobody knows it's a historic place," said city archaeologist Pam Cressey. "That's why we always try to display archaeological items where they were found."

For more than thirty years, the Snowden archaeological display and the Marshall House items have offered a point of reference to understand the historic significance of the buildings that once stood on the plot of land now occupied by the Hotel Monaco. Countless visitors examined the nonchalant gaze of the Jackson portrait and wondered about that block of wood with a large "U" that was once used to publish front-page advertisements for help finding lost slaves. When the Holiday Inn closed its doors several years ago, the Snowden exhibit was carefully packed up and returned to the Alexandria Archaeology Museum at the Torpedo Factory.

"The items on display at the Holiday Inn were only a small fraction of the items that were recovered from Snowden's privy," said Barbara Magid, curator at the Archaeology Museum. "The collection includes 14 pieces of lead type and several wooden spacers that were used during the printing process."

Interpreting the lives of Samuel Snowden and James W. Jackson is a goal for the Hotel Monaco, and Kimpton officials are eager to tell the story of this place to guests. But it's a haunted tale that has a few ghosts roaming about, just like the hotel itself. The hotel's manager suspects that the best place for such an endeavor might be the anteroom just off the lobby outside one of the conference rooms in the back of the ground level. Other potential places have been talked about since the hotel opened a couple of years ago.

There's something else at work here too, something so subtle that it tugs at the subconscious before it splashes across the consciousness. Outside, there's that plaque in celebration of the Confederacy. Inside, it's a different story. Each room has several color illustrations of Union soldiers standing at attention. They are usually in groups of three, although each room has its own configuration of artillery, cavalry and infantry.

That creates a kind of cogitative dissonance at the Hotel Monaco. From the outside, it's all stars and bars—chauvinistic pride in the Southland and commonwealth of Virginia. But inside, the joint is essentially under Union occupation, with multiple uniformed men stationed in each room. So while the outer wall facing King Street has the most pro-Confederate plaque in Alexandria, the interior is decidedly pro-Union.

"I'm not sure why the designer didn't find more balance," said manager Gregory. "It seems silly to ignore the other side of the conflict."

The hotel doesn't ignore the past. In fact, it does its best to filter the past through a modern lens to tell the Hotel Monaco story. There are variations on the theme, of course. And with each person, you hear a story slightly different from the last time you heard it. That's life in the big city and in this hotel that features colonial embellishments in context juxtaposed with Asian pillows and French draperies. The restaurant at the ground level is named Jackson 20, although a bust at the bar indicates the title is eponymous to President Andrew Jackson—not James W. Jackson.

"The history of this block is one of the reasons Kimpton was interested in purchasing the property," said Dan Underwood, former manager of the restaurant, shortly after it opened in 2008. "It's why we're here."

Here's a block that has almost as much history as the one dominated by City Hall. The old Marshall House was one of the key locations in the early days of the Civil War, one that became nationally renowned after Ellsworth and Jackson each became martyrs for their respective causes. But that's not the only important story to be told on this ground. The southeast corner of the hotel is harboring its own ghosts.

Meet Samuel Snowden. Born in 1776—yes, really—near Piscataway, New Jersey. Little is known of his life before he came to Alexandria in 1800, but soon after his arrival in the city he married Nancy Longden. Snowden's marriage to Longden on March 3, 1800, helped establish him within the framework of city life at that time. Her father was John Longden, the last living member of "Light Horse" Harry Lee's Legion—son to Thomas Longden, who was a volunteer in British General Edward Braddock's army. The Longdens' status and wealth served Snowden well, and the editor moved into the Longden house at 105 South Royal Street—where a backyard privy collected household items now in the possession of the city's Archaeology Museum.

Arriving in Alexandria in 1800 as a young newspaperman on the move, Samuel Snowden understood that the path to victory was domination. So the first thing he did was purchase the *Columbian Mirror* and the *Alexandria Advertiser*, two newspapers that would have otherwise been rivals to his new newspaper, which he called the *Alexandria Gazette*. There was another rival for a time, the *Alexandria Times*. But that folded in 1802 when publisher James Wescott moved into the District of Columbia to start the *Columbian Advertiser*. Because of Snowden's purchase of the *Mirror*, the modern-day *Gazette* traces its history to 1784—a lineage that includes three previous newspapers and one shared press. And, of course, this block where the Hotel Monaco now stands.

That press, purchased by Snowden in 1800, was the original press that published the city's first newspaper in 1784. When the *Gazette* replaced it in 1815, parts of the old eighteenth-century printing materials ended up in a well behind the house where Snowden lived with his father-in-law, John Longden, at 105 South Royal Street.

Some have suggested that those old letters and spacers—bits of the 1784 press—may have been given to Edgar Snowden to play with as a child. Little did anybody know that the son would follow in the father's footsteps and publish the *Gazette* for several decades. When the unit block of South Royal Street was excavated to build the Holiday Inn, Edgar Snowden's potential childhood toys emerged from rubble and debris—relics of a different era in Alexandria, detritus that helps Old Town understand its past.

The evidence taken from the Longdens' well on South Royal ties the modern newspaper to the one founded in 1784. The old letters and spacers, now in the possession of the city's Archaeology Museum, form a continuum between the past and the present, allowing a glimpse into another time.

Snowden was a Federalist, and he used his newspaper to advocate for manufactories, a protective tariff and an assumption of state debts. He favored

a strong national government, a broad interpretation of the Constitution and a financial policy that was based on industrialization, commerce and urbanization. Snowden was not a supporter of Thomas Jefferson, so when the General Assembly voted in 1806 to praise the "wisdom, virtue and firmness of the President of the Untied States," the newspaperman editorialized that the measure was "foolish and absurd." He later opposed President James Madison's ill-fated war against the British and excoriated Napoleon as the "Scourge of Europe."

"The *Gazette* was established in this place by the father of the present editor in 1800," wrote Edgar Snowden on January 2, 1871. "It is, therefore, one of the oldest newspapers in the United States. To have survived all the changes and chances of seventy years is not often to be recorded of any public journal in this country."

Nobody has ever reported the ghost of Samuel Snowden wandering around South Royal Street in the night. And the archives are silent as to any indication that Edgar Snowden's ghost lurks in the shadows of the Monaco, although the future of the newspaper industry does seem a bit haunted at present. Whatever the case with the Snowdens, it's clear that this place is very clearly haunted by breaking news from the distant past.

James W. Jackson was a hotheaded native of Kentucky who led a brief and violent life before arriving in Alexandria shortly before the war began. An anonymously written biography of Jackson was issued in 1862 by Richmond-based West and Johnson publishers—part of a wartime literary effort in which more than seven thousand patriotic volumes were written to create a national identity. The anonymous author of the Jackson biography clearly knew the tavern keeper personally, and the slim limited-edition volume documents the life of "the obscure and humble keeper."

"Whenever, in moments of passion or irritation, he injured a friend or attacked without provocation, he was always most prompt to acknowledge his fault, as soon as an opportunity offered," the contemporaneous biography states. "He instituted a series of 'hops' at his house, and whenever he encountered a good musician, he would call an impromptu 'ball' and afford the young people of the village an opportunity of enjoying themselves together."

When the Republican Party nominated Abraham Lincoln as a candidate for president in 1860, Jackson became a rabid secessionist, and Marshall House became the center of Alexandria's Confederate movement. As Virginia legislators convened in Richmond to consider seceding from

the United States of America, Jackson hoisted a thirteen-foot-by-eighteen-foot Confederate flag on a thirty-foot pole over the Marshall House and publicly dared the invading army to try and remove it. He greeted the news of Virginia's secession with a rollicking party at the tavern, which was followed by a pre-dawn raid by Union Colonel Ephraim Elmer Ellsworth—leader of a group of firefighters turned soldiers known as the "Fire Zouaves" from New York. Named for the Zouave regiments in the nineteenth-century

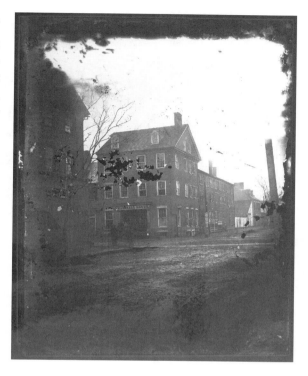

The Marshall House was located at the corner of King and Pitt Streets. *Alexandria Library Local History Special Collections.*

French army, membership in the Fire Zouaves was drawn from the ranks of New York's many volunteer fire companies. Ellsworth and his colorfully dressed men landed at the foot of Cameron Street and then seized the city's telegraph officer before spotting the giant Confederate flag flying over the Marshall House.

"Boys, that flag must come down," the colonel reportedly said.

Ellsworth entered the Marshall House with a handful of Fire Zouaves, climbed to the roof of the building, pulled down the flag, cut its halyards and began making his way back to King Street. But when he reached the half landing between the second and third floors, Ellsworth was confronted by a shotgun-wielding Jackson, who emptied the gun's contents into the colonel's heart. Ellsworth's lieutenant, Private Francis Brownell, returned fire and shot Jackson in the head. Within a matter of minutes, the war took its first two casualties at the corner of Pitt and King.

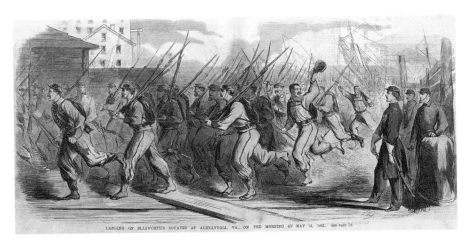

A newspaper illustration of the Union army invading Alexandria. *Alexandria Library Local History Special Collections.*

"News of the deaths spread like wildfire," wrote author Jeremy Harvey in the 2003 book *Occupied City*. "North and South now had the first martyrs for their causes."

The dramatic story of the May 24, 1861 double shooting was well known to many generations of Americans, who chose their folk hero according to which side of the struggle they identified with. A group known as the Sons and Daughters of Confederate Soldiers obviously sided with Jackson—and installed the undated plaque to mark the spot where their hero was killed "in defense of his home and the sacred soil of his native state." When the old 1785 building where these events transpired was demolished in the late 1940s, the language of the plaque was changed from "in this house" to "upon this site." When the Holiday Inn was built in 1972, the marker was moved again to its current location.

But the plaque clearly lacks balance. No mention is made of Ellsworth, a personal friend of Lincoln's, who ordered the colonel's funeral to take place in the East Room of the White House. Alexandria's roundhouse would later be the location where the railroad equivalent of Air Force One would later be built, a project that took so long that its inaugural use was the president's funeral in 1865. These days, all of those mitigating factors are swept aside by the plaque.

It doesn't even mention Brownell, the private who was later issued the Congressional Medal of Honor for killing Jackson. Now that the Hotel Monaco has revived the 400 block of King Street, some people are beginning to ask new questions about the plaque and its one-sided view of history.

The Alexandria rail yard workers spent years creating a presidential rail car. Its inaugural use was at Abraham Lincoln's funeral. *Alexandria Library Local History Special Collections.*

"I think of all the tourists to our wonderful city who will read this marker and go home with lies in their minds," wrote John Branchi in a 2008 letter to Alexandria Councilman Rob Krupicka. "Is this what we want? To honor the Confederate flag and the murder of our brave military personnel?"

Krupicka agreed with the letter writer and the Hotel Monaco's management that the plaque tells a narrow and one-sided version of the story. As a response, the councilman suggested, Kimpton could consider adding a new plaque that gave some context by telling the rest of the story. A new plaque on the outside of the building could join an interpretive display near the lobby in an effort to explain the complicated history of the block where the Hotel Monaco now stands.

"There is an opportunity for the current owner to provide some additional historic context here," said Krupicka. "They will have to determine the approach that makes sense for them."

Whatever approach has been taken at the Hotel Monaco, it hasn't prevented the building from experiencing a wide array of unexplained events. Ghost tour guide Ken Balbuena says that guests at the hotel will frequently see the ghost of a Union solider wandering through the halls with something draped around his shoulder. Perhaps, Balbuena suggests, it is that giant Confederate flag displayed by James W. Jackson. His version of events

includes dramatic tales of guests being confronted by the ghost of Ellworth, who moves toward the window in an effort to remove the flag from flying outside—the Confederate space where that plaque continues to welcome visitors at the intersection of Pitt and King. One of his stories involves a woman who had an encounter with the ghost of Ellsworth.

"As soon as she made eye contact, he vanished," said Balbuena. "Right into thin air, as if he was never there to begin with. But she had just seen him a moment earlier."

Strange things have also been known to happen around the hotel. One former concierge said that he heard loud, one-sided arguments that would take place late at night when nobody was around. He would look at the security monitor to see that the lobby was empty, even though he continued to hear the voice of the man arguing with some unheard second party. The concierge would rush out into the lobby to see what was going on, but nobody was there.

"Of course, there would be nobody there," he explained. "This happened several times when I worked the night shift."

Ghost tour guide Randolph Bragg tells a similar story. It involves guests who are staying at the hotel hearing the sound of a loud argument taking place in a stairwell. The argument is followed by the sound of footsteps, descending or ascending a stairwell. Bragg says the jarring sound of the argument and the intrusive noise of the stairwell footsteps prompted one of the guests to complain the next morning—only to learn the shocking truth.

"There are no stairs on that side of the building, at least anymore," Bragg explains. "That's the spot where Jackson confronted Ellsworth."

CHAPTER 7

GHOSTS OF RED HILL

CLOAKED WOMAN HAUNTS BRADDOCK HEIGHTS

Much of the rhythm of life in Alexandria's early days rested on the baroque beats of the Potomac River. Men would leave on seafaring missions to make money, and they would return when the job was done. Life on the open waters was nasty, brutish and short, what with disease and pirates and unscrupulous captains looking to undercut an enemy. Making a living as a captain was a rough life, and the trade was filled with rough men. For the women who loved them, the rhythm of their lives tended to mirror that of their seafaring men.

One of these women is at the center of our next story, which takes place on a peaceful bluff known as Red Hill overlooking the port of Alexandria. Here we find an old house, no longer around, known as the Anchorage. The captain and his lady lived here, on an elevation so steep that one could easily see the action along the riverfront and the comings and goings of every sloop on the shore.

The mists of time have obscured the names of this couple or even the exact date of their time here. But their story remains an important part of the city's folklore—lodged into the collective unconscious of garden clubs and neighborhood associations that have passed the story from one generation to another. It's a story of love and loss, universal themes to be sure. And ones that have long struck a chord at a place now known as Braddock Heights.

There are still some veteran residents who refer to this section as Red Hill, an area that runs along a heavily wooded section of Russell Road in the northwest part of the city. It's bisected by Braddock Road, which runs up the

Alexandria's waterfront was the center of city life for many years. *Alexandria Library Local History Special Collections.*

hill to the west. This is where the famous British General Edward Braddock marched his troops up the hill in 1755 during his ill-fated appointment with destiny in the wilderness known as the Ohio country. It's possible that the road itself has a sense of regret carved into its ditches. Shortly after Braddock's death in battle, according to tradition, is when the captain and his lady built the Anchorage.

Not much is known of the reclusive couple. They lived in a world of seclusion in a little cottage surrounded by an orchard and luscious gardens—the kind of place that offered a welcome retreat from months on the open sea. Even today, the name Orchard Street transports us out of the urban grid in Old Town. Back then, this hilltop vista offered the captain and his lady a sense of solitude, far from the dirty sailors congregating along the fetid riverfront. Because the couple kept to themselves, rumors circulated about the two.

Some said that the couple were witch and warlock. Others said that they were merely antisocial. Whatever the case, the two seemed to be very much in love. The young wife used to watch from the top of Red Hill to see the masts of the tall ships as they set sail for distant ports of call. She would keep watch until she saw the return of her captain, toiling in the garden and waiting for his return. When the captain arrived, the lady would greet him with a warm embrace, and the couple would retreat to the silent solace of the Anchorage. This became a steady ritual on Red Hill, one that neighbors came to expect yet watched from a distance.

Then, one day, the captain did not return. It's not clear what exactly happened to the man. Some say that he was struck with a severe illness. Others say that he died at sea. It's possible that he later returned to town and was shocked by what had happened in his absence. Whatever the case, he was not aboard his ship when it returned to Alexandria's dock. When the

lady realized that the captain was not aboard, she became so overcome with grief that she arrived at the conclusion she could not go on.

She shot herself in the same garden that she so lovingly cared for in his absence.

"There are said to be remnants of the garden still left on Hanson Lane and over the years there have been persistent reports of a tall and slender woman with lustrous eyes and dark hair who is seen wandering in the area until she is spoken to," wrote neighborhood historian and newspaper reporter Frances Lide in a history of the North Ridge neighborhood. "Then she disappears."

The legend of a ghost haunting Red Hill has lingered for years. Residents of the neighborhood have long experienced regular sightings, reporting the presence of a tall young woman described as quite slender with large lustrous eyes and a mane of black hair. Accounts of sightings date back to the 1920s, although it's likely that previous encounters may have escaped into the memory of those unwilling to share the story of this mournful ghost. One woman is said to have seen the ghost and invited her in, only to witness the apparition vanish into thin air. She later described the encounter with a native of Alexandria.

"You saw the ghost of the sea captain's wife," the woman responded, according to the most popular account.

The ghost is said to wear a cloak thrown carelessly around one shoulder. Again and again, the ghost of the brokenhearted woman has been spotted in the garden at the crest of the hill where the cottage once stood. Although she has been seen lurking around various spots in the neighborhood, especially on overcast days, she is most frequently seen along Hanson Lane. She has been known to come and stand by what was once her garden.

The woman always seems anxious to speak, but then she silently wanders away. She seems so real that people mistake her for one of the living. But she is not. She is, in fact, a ghost.

Sadly, the Anchorage is long gone. And the garden the woman once tended so lovingly while her captain was away was swallowed up by 1950s-era development. But even today, the traces of that old garden can be seen: a hedge here, a gnarled old apple tree there. These are but the vestiges of what was once a handsome orchard. The steep bank where she watched in vain for her loved one is a well-known stretch of Braddock Road, an elevation that still offers a scenic overlook of Old Town and the river with a glimpse of Maryland in the distance.

The scenery motivated artist Babs Van Swearingen. In the 1950s, she included the legend of Red Hill in a series of watercolor paintings depicting

Artist Babs Van Swearingen portrayed the ghost of Red Hill wearing a red cloak. *Alexandria Lyceum.*

famous ghost stories in Alexandria. In a 1956 *Washington Post* article, Swearingen explained that her favorite work of the series was the one called *The Captain's Lady*. According to pioneer female journalist and North Ridge historian Frances Lide, who was then a reporter for the *Post*, the fact that the Red Hill painting is her favorite "might be partly because she, too, is a captain's lady. Her husband, Navy Capt. E.K. Van Swearingen is currently stationed here."

Van Swearingen told Lide that she first became intrigued by the legend of the captain and his lady after reading a newspaper account detailing the story of the Anchorage and the history of Red Hill. She would go on to paint four other paintings about famous ghosts that haunt Alexandria, but something about *The Captain's Lady* stayed with her. Essentially, she couldn't shake it.

"I'm not psychic," said Van Swearingen. "But I kept seeing the captain's lady after I learned her story. And I'm very sure that the cloak she is wearing is red."

Sure enough, that red cloak leaps out of the painting and into the viewer's memory, haunting the soul with this classic tale of love and loss. In one rather Shakespearean version of the story, the captain returns to Red Hill to find that his only true love has committed suicide. So he shoots himself in the garden. But that may be a fanciful twist to evoke memories of Romeo and Juliet or even Alexandria's own story of Laura Schafer and Charles Tennesson.

The ghost of the captain's lady is not the only ghost haunting this neighborhood. In a series of essays published by the North Ridge Neighborhood Association, Lide points out that this famous story is "just about the only house story which was printed in the popular press on the history of this area." But there is another house she points out in another section of the book, one that has its own history—and, perhaps, its own ghost.

"A residence generally considered to be one of the oldest in North Ridge is also on Red Hill in the vicinity of the legendary Anchorage," Lide wrote in *North Ridge Lore*. "Its driveway is located at 305 West Braddock Road, though it faces Orchard Street."

Today, there is no driveway on Braddock Road. Don't try to walk there, because there's no sidewalk on this heavily wooded section of Braddock Heights. In fact, the only indication that there was once a street address at 305 West Braddock is a series of stairs leading into a thicket of woods. The house is almost hidden in the trees and shrubbery, but it's one of the most significant spots on the cultural map because it's one of the oldest in the

The front steps to 305 West Braddock. *Photo by Louise Krafft.*

area. The original part of the house dates back to 1810. Like many other large houses of the era, it became a hospital during the Union occupation of Alexandria. A second-floor bedroom is believed to have been used for surgery because of its good northern light. Neighborhood residents say that the floorboards were so stained with blood that they could not be cleaned. According to historian Ruth Lincoln Kaye, this is where yet another ghost of Red Hill may be lurking.

"Present occupants can give no rational explanation for the strange sounds they hear from time to time, like footsteps going up and down the stairs," Kaye wrote in a 1975 compilation of Alexandria ghost stories. "Neighbors claim they have long seen or heard of the ghost, or ghosts. A child has in recent years seen a ghost in long white dress on the stairs."

Why is this secluded old house haunted? Perhaps, Kaye wonders, it's because of what happened here in the 1860s. That's when Union soldiers occupied the city and confiscated property at will. Alexandria was an occupied city, and it was certainly an important stop along the railway headed north. That meant that the city became crowded with dead and dying Union soldiers. Public buildings, hotels, churches and even homes were confiscated and transformed into makeshift hospitals.

This is what happed to 305 West Braddock. In her book *Legends and Folk Tales of Old Alexandria*, Kaye speculates that the strange sounds and occasional apparitions reported here in years past could be the ghost of a soldier who died on the second floor operating room. It's not outside the realm of possibility, Kaye suggests, that the old soldier continues to roam about.

"Perhaps the treading of feet on the stairs dates from Civil War time, the ghost of a soldier who died in the operating room," Kaye wrote. "Perhaps it is that of a child coming to look for its long lost china-doll, found buried in dirt in the garden not long ago. Or perhaps it is the peripatetic sea captain's wife."

The neighborhood is known to have several other ghosts prowling its paths, including everything from a stamp collector to a mysterious garden sprinkler. The suburban nature of the neighborhood can be explained through the stories, which include a mysterious car following motorists in the night to unexplainable azaleas. The best collection was published in a 1981 article in the *Alexandria Gazette* by former North Ridge Citizens Association president Bob Leider.

Let's start with the ghost car. Unlike Old Town, North Ridge is connected by an undulating warren of streets. The layout is more reactive to the natural topography than the other way around. That means that the streets twist and turn, sometimes quite dramatically so. One major thoroughfare is Cameron Mills Road, home of George Mason Elementary School. But driving on this vista is not child's play. There's a ghost car haunting the streets.

Late at night, drivers on Cameron Mills should be able to expect to have the road to themselves. Although an important avenue in North Ridge, it's not a connector street linking two sections of the city. As Lieder explained in his lyrically written account of ghost tales in North Ridge, neighbors here first began seeing the ghost car following them on Cameron Mills near Enderby Drive. But the car was following at a safe distance, so what was the harm? By the time drivers passed the crest near the fire station, the mysterious trailing car was gone. So they didn't think much about the situation.

Until they saw the car a second time. Then a third. By the time it happened a fifth time, people really began wondering what was going on. Some tried slowing down to five miles an hour and pulling to the curb, hoping that the car would pass. But it didn't. It also slowed down and pulled to the right. Others came to a full stop. But so did the ghost car. Ultimately, many drivers gave up driving Cameron Mills altogether in favor of taking nearby Valley Drive.

About six months after first hearing the story, Lieder found himself driving Cameron Mills at 2:00 a.m. After pulling away from the four-way stop at Chalfonte Drive, he saw the lights in the rearview mirror. They stayed behind him until they reached the fire station and then they suddenly disappeared.

"Did you see the lights?" Lieder asked his wife.

"Yes," she said. "They were awfully bright."

"I did not want to tell her. The lights were not that bright," Lieder explained. "They just sat very high on the car, as they did in the '30s and '40s, and shone right into the rearview mirror of our new, long-slung guzzler."

When North Ridge residents finally arrive at home, they are greeted by some spooky happenings there as well. In many instances, the events are tied to the gardens—fitting considering that the ghost of the Captain's Lady is also said to haunt the gardens of North Ridge. One famous story involves mysteriously blooming azaleas, and the other story involves a garden sprinkler with a mind of its own.

First, the azaleas. As it happens, there was a Mrs. S who was extremely proud of the azaleas that covered a large slope of her house near Washington Circle. She was meticulous about watering, fertilizing and pruning the bushes. And every May, her investment would pay off in a burst of blooming red, pink, purple and white. But Mrs. S eventually came to an age when she could no longer take care of the azaleas, so she sold her house on Washington Circle and moved into a condominium.

Enter Mr. O. He didn't care much what the azalea bushes looked like, and he made no effort to care for them. Although the older ones could handle the abuse, the newer ones turned brown and died. By the time spring arrived, Mr. O's bushes looked raggedy, with patches of color checker-boarded among dead branches. Not long after that, Mr. O decided he had enough of the neighborhood and wanted to move. So he approached a real estate agent who knew that the best way to sell a house was through newspaper advertising.

So the Realtor grabbed her Nikon and drove to Washington Circle. It was a cold, gray day in November when she snapped the photo and took it to be processed. This was a time before digital cameras made everyone so impatient with photography. Anyway, by the time the Realtor received the developed film, something strange had happened.

The house in the photo did not have an imposing gray sky, as was the case when the photograph was taken. Instead it had a glorious soft blue expanse. The trees were not dead and dying, as they were that chilly November day. Instead, they had new leaves clinging to the branches. And then there were

those majestic azaleas, in full bloom despite the fact that it wasn't May and that nobody had taken care of them since Mr. O sold the house. Needless to say, the real estate agent was dumbfounded.

"She could not explain what happened, but I think I can," Lieder wrote. "The azaleas—those were dead and those that struggled to remain alive—had gathered all their strength to help move the house into hands that would be kind to plants."

Staying with the theme of haunted gardens for a moment, let us consider the story of Mr. G. As Lieder tells the story, he bought a house on a winding street off Braddock Road. The previous owner built shelves everywhere—in the basement, laundry room and garage. At first, Mr. G. had no use for the shelves. But then in December, he decided to bring in the garden hoses and store them in the garage. While moving them, he took a good look at the shelves for the first time.

They were covered in dust and a few dead crickets. And in the far corner, there was an old white lawn sprinkler. Well, Mr. G. already had a sprinkler, so he had no use for this one. He put it in a box headed to Goodwill for donations. He forgot all about that old white sprinkler until the spring, when he returned to the shelf to get his hoses. There was the sprinkler, in the exact same spot as the first time he had seen it.

"Did I give this thing to Goodwill?" he asked himself. "Or did I just mean to give it to Goodwill and plain forget?"

Once again, he donated the old white sprinkler. But in December, when he was moving the hoses back to the shelf, there it was back in its old home.

"It's there for a purpose," he explained to Lieder. "But I don't know what that purpose is. It probably hasn't happened yet."

Perhaps the purpose was to make the man think of fire and consequentially purchase fire insurance, which is how his story ended. Or maybe it was just another old North Ridge ghost, one that's always in full bloom at the witching hour. Following behind drivers in the winding streets of this community are a number of spirits and legends, everything from Civil War soldiers to mourning lovers. And every spring, the flowers here put on a show that haunts the imagination.

CHAPTER 8

HOUSE OF CARDS

CHILDISH GHOSTS ARE BLOWING IN THE WIND

Legend has it that Thomson Mason won his urban plantation estate in a hand of cards and became the third mayor to live there. Perhaps this means that he was good at both politics and poker. Yet he was a player who did not win every round of the game. Maybe that's why Colross is haunted.

Don't look for the old plantation estate today. It's long gone, although not demolished like many other historic prizes that met the wrecking ball during the period of so-called urban renewal. Unlike those long-lost painted ladies who were snuffed out of the downtown scene in the 1960s, Colross was moved to New Jersey, where it currently is in use as a school. But the move left something behind, perhaps even the ghosts of children playing a perpetual game of foxes and goose.

Like a game of hide-and-seek, the ghosts haunting Colross are concealed in the shadows of a building now known as the Monarch. The six-story tower raises from a spot near the old vault that would not remain locked, frequently and unexplainably found wide open and swinging in the breeze. At the base of the tower is a Starbucks, where the children have been known to engage in some mischief. Here's a story almost unknown in Alexandria but one that's documented in numerous places at the Alexandria Library's Special Collections Department.

"The grounds included a whole square block," explained Betty Smoot, who owned the property in the mid-nineteenth century. "And were enclosed with an ancient brick wall, ten feet in height."

Smoot is one of the many who felt the presence of the ghosts haunting Colross, children who died too young and refuse to leave their eternal

Colross Plantation was located at 1111 Oronoco Street. *Alexandria Library Local History Special Collections.*

playground. Why should they? Here was everything a child could want: beautiful gardens to roam, a spacious yard, a universe of city politicians and rotating cast of hangers-on. Ghost tour guide Ken Balbuena suggests that this sense of dewey-eyed virtue may be at the heart of this tragic tale of innocence lost.

"It's often said when children die violent deaths, they don't realize they've died," explained Balbuena. "Perhaps William and Ann didn't know they were dead."

Colross was all but forgotten when a wealthy development company began unearthing part of the 1100 block of Oronoco Street. That company, New York powerhouse Diamond Properties, was the top contributor to Mayor Bill Euille's reelection campaign in 2006. Zoning for the high-end condos took place at a time when the go-go market for housing in Northern Virginia was a bit too hot. By the time the economy cooled a bit, the condos were sold as apartments derisively called "condopartments."

The project was moving along swimmingly when, suddenly, something strange happened. The ghosts of Colross reemerged from underground. It was almost like the vault was being unlocked, and spirits from long ago were among us. During construction, workers removed a concrete slab from the twentieth century. Hiding underneath was the basement of Colross, the long-lost and largely forgotten urban plantation home of Thomson Mason. According to Alexandria's strict archaeology code, this meant that all construction had to come to an immediate halt while the developer paid for a team of archaeologists to arrive on the scene and conduct an extensive study.

The investigation stretched from April 2005 to January 2006, unearthing buried walkways and foundations in the southeastern quadrant of the block. All of the features were photographed, documented and mapped. The burial vault was excavated, and no human remains were discovered inside. Apparently, their graves had been moved somewhere else. Or had they?

"After a while, with a site like this, you've discovered all that you are going to find," explained Williams during a 2005 tour of the archaeological site. "And then it's just more of the same."

This is the scene of our next legend: Colross, where the spirits of mischievous children continue to haunt the block today. The story begins in 1799, when a wealthy Alexandria businessman by the name of John Potts purchased the block for $100 down in silver and an annual rent of $133 plus taxes. Construction began in 1800 but Potts fell on hard times. He eventually had to mortgage the property to secure a loan for his business ventures. In 1801, he took out an advertisement in the *Alexandria Gazette* for a "large and Handsome Brick Dwelling House, fifty by forty feet, with a Brick Stable, Smoke House and Well of Excellent Water."

Enter a man named Jonathan Swift. He stepped into the breach, saving the mansion for future generations. City records indicate that he paid $9,000 for the estate and moved in with his wife and children plus three slaves. Potts named the property Belle Air or, later, Grasshopper Hall. He would later rise to prominence as man at the center of city politics, serving as mayor from 1822 to 1823. He died in 1824, and although his body is rumored to be buried near the house, archaeologists have not been able to locate it.

Nobody is really quite sure what happened next, and the record isn't clear. Some say that the house was acquired in a game of cards. Others say that it was purchased. Either way, it's clear that the new occupant of this urban plantation was none other than Thomson Francis Mason, grandson of George Mason and member of one of the first families of Virginia. George Mason is known as the "Forgotten Founder," largely for his opposition to the Bill of Rights. But Thomson Mason could just as easily be known as the forgotten founder of Alexandria.

This was an era when the seaport was buzzing with activity. A quick scan of the advertisements published in the 1820s *Alexandria Gazette* reveals a world of maritime commerce with its own rules. The daily roster includes ships departing to Baltimore or Barbados. The warehouses along lower King Street were stocked with calico and bourbon. And Thomson Mason was at the center of it all.

Over the years, he also served as an attorney, jurist and judge. Clearly, he was a leading member of the bar from the era, arguing cases at the Hustings Court overlooking Market Square. After establishing himself downtown, he began attending political meetings at Rhodes Tavern. In 1824, he stood for election at the tavern and won a seat on the Alexandria City Council. Mason rose to power quickly, becoming mayor after his first three-year term at City Hall. His three years as mayor were prosperous, and *Alexandria Gazette* readers of that era were treated to a wealth of information about which products were arriving daily along the waterfront. The job of mayor was a rotating position in those days, with the job passing along to another member of City Council after the term expired.

"We know that Thomson Mason was a gambler," said Balbuena. "And clearly he was a winner, most of the time."

Returning to his position as a member of the Alexandria City Council in 1830, he was elected to the fourth ward at Indian Queen Tavern then and the third ward again at Rhodes Tavern in 1833. Mason stepped off Alexandria's public stage in 1836, returning to the shade trees of his majestic urban plantation out west on Oronoco. Here, among those gently curving brick walkways in the garden at Colross, a cold wind was about to blow tragedy through the serenity. Three hurricanes would later ravage the plantation estate. Even then, the winds were beginning to blow at Colross.

Thomson Mason was not fond of this "Belle Air" business. And "Grasshopper Hall" sounds like some kind of backwoods tavern. Dignity required something more majestic. The origins of Colross are murky, but the sound of the word does seem to evoke some kind of lost spirit, creeping along Oronoco. The first thing he did with his new estate was ditch the names.

Belle Air and Grasshopper Hall were out; from now on, this place would be known as Colross.

Accounts from Mason's day say that a "pretty old garden" flanked the house, with impressive wings and various outbuildings. Airy rooms were situated on either side. Cupboards and closets were without number. Dark cubbyholes filled the attic. Some narrow hallways and back stairwells apparently went nowhere. But it sure was impressive from the outside. One contemporaneous account describes it as "probably the largest and most beautiful mansion ever erected in Alexandria." The traditions of the house were, in the words of Margaret DuPont Lee, "deeply rooted in the soil of Virginia, and its history lends atmosphere, romance and charm to the old town."

No wonder this place became haunted. This is a house that was practically begging for ghosts. And that's what it was about to get. After taking possession

Accounts from Mason's day say that a "pretty old garden" was part of the estate. *Alexandria Library Local History Special Collections.*

of the house and changing the name to Colross, Mason constructed a large garden wall. It was the tallest wall in Old Town. The garden wall served to protect the mansion from the prying eyes of the neighbors. But it also became something of a landmark. In later years, the wall would serve as the location for three high-profile shootings—one of a notorious bounty jumper and two Civil War deserters. For years, that old wall was said to be the location of a ghost.

But that was later. For now, this was an idyllic place to grow up for the two Mason children, William and Ann. The children loved playing games, especially one known as foxes and goose. That's *foxes*, plural, and *goose*, singular. According to tour guide Ken Balbuena's version of events, this was a childhood game that involving concealing one's existence as long as possible and then giving chase when the jig was up.

"It's kind of like hide-and-seek," explained Balbuena. "But it turns into a game of tag."

According to the well-known legend of Colross, William and Ann were playing when the winds started to pick up. At first, it was brisk. But the speed and ferocity began to build momentum. Before long, the chicken coop where William was hiding began to lose its structural integrity. It began to sway in the breeze, leaning farther and farther as the chicken coop gave way.

"Gale-force wind gusts toppled the creaky old building and killed him instantly," wrote ghost historian L.B. Taylor in the first volume of the popular "Ghosts of Virginia" series. "The house was in mourning for none took it harder than young Ann."

Two days later, Ann drowned in a bathtub. The way Balbuena tells the story, her head slipped under the water. The nanny discovered the shocking scene, which served to double down the tragedy at Colross. The seal was now broken. The scene had drawn to a dark finish, with death claiming two bright young lights before they even had a chance to shine. This place would be haunted soon enough.

The Masons could not bear living at Colross after such unspeakable tragedy. Before long, they had passed from the scene, and the Smoot family moved in. But things were not as they seemed at Colross. The ghosts of William and Ann haunted the place, after all. And who wants to live in a haunted house?

The answer to that question is the Smoots. They are one of Alexandria's leading families, owners of a prominent lumber business for many years in Old Town. The Smoot family is the main reason we now know about the ghosts that haunted Colross. For starters, let's consider that vault where Ann and William were buried. According to the Smoot family, the large iron lock refused to stay locked—allowing whoever, or whatever, was inside the ability to roam about creation. Defying the course of nature, the lock never rusted, even though it was constantly exposed to the elements. It was never broken, but it would never remain shut, either.

"Father would lock it himself," said one of the Smoots, according to Taylor. "And open it would come."

Since then, legend has it, the two children have haunted the grounds. The sound of children's playful laughter and restless antics have been heard on the site for years, and some say that the William and Ann inhabit the block in a perpetual state of ghostly childhood. Residents of the house reported hearing the distinct sound of children playing on the grounds, even when no children were in the house. The sounds of giggling, singing and talking were ever-present.

"Their cheerful presence was so strong, in fact, that successive owners at Colross had great difficulty in retaining servants there," explains Taylor. "And while these sightings recurred over a period of thirty to forty years, the children, always dressed in pre–Civil War clothing, never grew older!"

The curse didn't stop with the Mason family. Hurricanes destroyed large portions of the house in 1850, 1895 and 1927. For the record, that's three hurricanes that ravaged the house and three mayors who lived there. One particularly haunting photograph from 1927 shows two unidentified children standing before the hurricane-ravaged Colross. Who were these children? The photograph gives no indication, but some think that they might be William and Ann. There is a certain dark continuity in this legend, with a gust of wind killing young William at the same location later ravaged

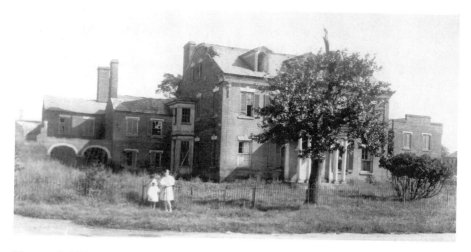

Unnamed children stand outside Colross after a hurricane battered the estate in 1927. *Alexandria Library Local History Special Collections.*

by three hurricanes and a ghost story that can be heard blowing in the wind of an area some old-timers still call "Uptown."

"Oddly enough," explains Balbuena, "the wind seemed to be confined to the area around the vault."

The estate would eventually become the possession of a wealthy businessman who lived the big life until the stock market crash of 1929. What happens next is somewhat of a mystery. Some say that he was shot by a deranged man. Others say that he committed suicide. Whichever version of events you choose to believe, perhaps you can now see why Colross is indeed one of the most haunted spots in Alexandria.

"People could often find its gate swinging back and forth," said Balbuena. "Constantly squeaking open before slamming shut all on its own."

William and Ann were buried in a vault. That much is certain, according to city records and archaeological investigation. The report issued by the developer's archaeological consultant quotes contemporaneous accounts explaining that the burial vault was "done away with" and that "the remains were removed to a cemetery" when the Smoot family owned the house during a later period. The archaeological investigation concluded that members of the Mason family were moved to Christ Church Cemetery.

Early in the twentieth century, the house was moved to a site in New Jersey. And by the dawn of the twenty-first century, Colross had been all but forgotten. In recent years, the site became home of Hennage Printing. In the

winter of 2003, Diamond Properties acquired the property and announced a plan to build the Monarch, a high-end condominium building with ground-floor retail a short walk from the Metro. The housing market was booming, and the developer was eager to move forward.

But then something strange happened. It wasn't a ghost, necessarily. But the developer was certainly haunted by the past. They certainly paid the bill for R. Christopher Goodwin & Associates, whose associates assembled the meticulous catalogue of what was discovered hiding in the soil at Colross.

"It's amazing that anything survived," said Martha Williams, the consultant's historian in 2005. "I don't think that anyone was prepared for what did survive."

Each new discovery added to the existing body of work while simultaneously suggested new questions. Why was this plantation built in the urban core of the city, and what was life like for its inhabitants? Archaeologists discovered an intact basement, including an elegant herringbone floor. The design was repeated in several walkways that connect the main house at 1111 Oronoco Street to numerous outbuildings, including a kitchen, a cistern, a stable and other buildings whose purposes are still unknown.

Today, the past has been all but obliterated. The block where Belle Air once stood, a spot later known as Colross, contains no trace of its history. Most residents in the condopartments have never heard of Thomson Mason, and they know nothing of the ghosts that are known to haunt the place. But that doesn't mean that the hauntings have stopped now that modern life has intruded into the picture. Far from it. In fact, the ghosts are apparently just as alive and just as impish as ever.

Just ask Tammie Carothers, lifelong resident of Alexandria who now works in the Starbucks at the corner of Pendleton and Henry Streets. She didn't learn about Colross until recently, and she was blissfully unaware of the childlike ghosts that were said to haunt the block until approached for a comment about the legendary hauntings. That's when she realized what had been happening.

It seems the milk containers at this particular Starbucks won't stay shut. Like the vault that continued to swing open when a gust of wind came through, the milk jugs refuse to stay closed. Carothers says that the tops will unexplainably fly into the air for no apparent reason. Nobody is touching them or even near them. They just pop off, as if some kind of unseen force is acting on them.

"Now I'm scared," she said, widening her eyes after selling an iced coffee on a recent afternoon. "This happens all the time, with the tops just popping off the milk. It happened right before you came in here today."

THE HAUNTED MANSION

WOODLAWN IS THE MOST HAUNTED HOME IN VIRGINIA

Everybody at Woodlawn Plantation seems to have a spooky story about something strange that has happened at the historic house—a well that's a conduit to the underworld; the sound of footsteps from otherwise empty rooms or music from a Wurlitzer organ that doesn't exist; or a notorious portrait that can't seem to stay on the wall.

Built in 1805 for Martha Washington's granddaughter, Eleanor "Nelly" Parke Custis, and her husband, Major Lawrence Lewis, Woodlawn passed through several owners before ending up as a museum operated by the National Trust for Historic Preservation. Many generations have passed through its walls, and some people will tell you that their spirits are still wandering around the building.

"Woodlawn is one of the most haunted houses in Virginia," said Carole DeLong, a tour guide at the museum. "There have been so many sightings over the years—not by me, although I have heard a baby crying and a cat hissing."

Set atop one of the steepest hills in the region, Woodlawn is guarded by stately oaks and elegant bushes. It's a throwback to a more genteel time in Virginia's history. And, yes, it's haunted. You don't even need to hear one of the many stories about ghosts at Woodlawn to know. Take a glimpse at the place. It *looks* haunted. One visit, and you'll know the place is spooked before you hear the first story.

Woodlawn's reputation as one of Virginia's most haunted houses was the stuff of local legend for years. Recent years have seen its standing take

Woodlawn Plantation has been called the most haunted house in Virginia. *Library of Congress.*

a broader hold. In his popular "Ghosts of Virginia" series, ghost-hunting author L.B. Taylor refers to Woodlawn as "the most haunted home in Virginia." The most complete collection of supernatural stories at the historic house is chronicled in a slim volume titled *Ghost Stories of Woodlawn Plantation*—a book that suggests that George Washington's spectral presence has been seen riding around the property on a white horse, that furniture mysteriously moves around the house without setting off the alarm system and that a well in the basement of the house creates a link to the underworld.

"More than half of the reported ghostly sightings have occurred when the well lid has been closed," wrote Brian Taylor Goldstein. "There have been several instances when the lid has been expressly shut at night only to be found open the next day, usually with whatever has been placed on top of it crashed to the floor."

Perhaps the most notorious object in the house is an oval-shaped portrait of Edward Butler, the son-in-law of Eleanor "Nellie" Parke Custis Lewis. Apparently, Butler and his mother-in-law had a notoriously bitter relationship, one that soured when it became clear that he would not be named inheritor of the estate she controlled after the death of her husband. Letters she wrote during this period contain surprising diction for a lady of

her status during this period. His painting seems to have a hard time staying on the wall, leading to a spirited debate at Woodlawn: Is Lewis's ghost knocking her nemesis off her wall, or is Butler's ghost causing mischief?

"There was one woman who walked into the room where Edward Butler's portrait was hanging, and she had to leave the room immediately," said Dottie Palmer, who works in the gift shop. "She said that she felt the presence of evil, and she had this overwhelming feeling that she had to get out of the room as soon as possible."

The plantation was a wedding present from George Washington to Martha Washington's granddaughter, Nelly Custis, and Lawrence Lewis in February 1799. Lewis was an old friend of the general's, a man who served with him in the army and who later was called to service at Mount Vernon to act as host to the many well-wishers arriving at the plantation on an almost daily basis.

When Lewis set eyes on beautiful young Nelly Custis, it must have been love at first sight. The couple hit it off and eventually became engaged. Washington was thrilled by the prospect of inviting his friend into the family, so he set aside two thousand acres of his own eight-thousand-acre estate. It was to be called Woodlawn, a perfect name considering the lush foliage that still envelops the site today. Renowned architect William Thornton, architect of the Capitol in D.C., was hired to design the place.

"A most beautiful site for a gentleman's seat," Washington is said to have declared.

Although Washington personally selected the site and rode out there several times with Lewis and Thornton, he died before construction began in 1800. This was Woodlawn's first tragedy. Perhaps this is why legends have persisted over the years that Washington himself has haunted the house for many years, especially on cold, moonlit nights. He apparently circles the drive on his great white horse in the vicinity of the boxwood.

Washington is even said to be making a cameo appearance in a photograph taken by Ed Barr, who was at Woodlawn to take pictures of a needlework show. After developing his film, Barr was amazed to see the shadowy image of a man's leg wearing buckled shoe and stockings. Barr is not the only photographer to have captured patches of gray light in hallways and staircases.

"Billowing smoky patches and circles of grayish matter have shown up in numerous rolls of developed film," wrote Woodlawn historian Judy McElhaney. "One could almost dismiss this as a result of bad film, a faulty camera or just plain trickery if it were not for the fact that so many different people have used so many different types of cameras over the years."

The Lewises continued living at Mount Vernon with Martha Washington and the slaves until 1802, when the north wing was ready. By the time the stately house was complete in 1805, it consisted of a large central block and north and south wings connected to the main block by connecting elements of Palladian architecture known as "open hyphens." Constructed entirely of slave labor, Woodlawn was built with local materials and a sense of craftsmanship that is unmatched, even today. This is an estate built to withstand the test of time.

The grand scale of Woodlawn made it a perfect location for lavish entertaining. The couple hosted the prominant names of their day, everybody from Zachary Taylor and Marquis de Lafayette to Mrs. Robert E. Lee. The plantation acquired a reputation for hospitality and style that was unrivaled in all of Virginia. It was a Camelot of sorts, a glamorous high life at the center of the commonwealth's upper echelon. But, like all things, it was destined to pass into the mists of history.

Lawrence Lewis died in 1839. Nelly moved to a plantation known as Audley, which was built by her only surviving son, Lorenzo. She lived there for many years until her death in 1852. She survived her husband and all of her children, except her eldest daughter Parke. In fact, death loomed over Woodlawn. Five of the eight children born to the Lewises died, most in infancy.

By 1846, Woodlawn was in the hands of Quakers from Philadelphia. They cut down the estate's lush trees and sold them for ship timber. Unlike the Lewis family, they weren't interested in living the life of Virginia gentry. Instead the modest Quakers used the mansion as a school and meetinghouse. The land was divided and sold to liberated slaves once owned by the Washingtons and Lewises.

In the early 1850s, the mansion and five hundred acres were purchased by John and Rachel Mason of New Jersey. The Masons and their descendants lived here until 1892, when they put the house on the market. But nobody was willing to purchase the storied old haunted mansion. Then a hurricane swept through Northern Virginia in 1896, and the house was left abandoned for six long years—a hulking shell of its former self, battered and desolate.

By the dawn of the twentieth century, it was rescued by a New York playwright by the name of Paul Kester and his brother Vaughn Kester, a novelist. In 1902, the brothers moved in with their mother and sixty-seven cats. That last sentence bears repeating. The Kesters restored the grand dame to its original splendor and raised the hyphens to their present height. The old estate burst into life again, this time with an oddball assortment of actors, artists and performers.

Playwright Paul Kester lived at Woodlawn with sixty-seven cats. *Library of Congress.*

By 1905, the Kesters set their sites on Gunston Hall, the plantation estate of "Forgotten Founder" George Mason. So they sold Woodlawn to Elizabeth Sharpe of Pennsylvania. She made extensive renovations and lived there until her death in 1925. The house was then purchased by Senator Oscar Underwood of Alabama. The Underwoods created a large formal dining room in the south hyphen and a ballroom in the north hyphen.

Senator Underwood died in 1948, when the house passed into the possession of a group of local businessmen. Eventually, the estate was acquired by the National Trust for Historic Preservation. Today, the house has been interpreted to reflect the Lewis era. About 130 acres of the original 2,000 acres remain, and the old slave quarters are now the location of the Woodlawn Shopping Center and Fort Belvior.

Visitors to Woodlawn often report that there is something about the house, something about the experience. It's more than meets the eye, and it's often more than folks bargained for. The house has this reputation of being the most haunted home in Virginia, after all, and it never fails to disappoint. The intangible nature of haunted Woodlawn was perhaps best captured by author Brian Taylor Goldstein, who penned the dazzling introduction to *Ghost Stories of Woodlawn Plantation*. His explanation is captivating:

Even in the reassuring light of day, when the sun chases all the shadows into far corners, there is an other-world feeling. It exudes from each brick and stone, from the earth itself, as if voices were trying to make themselves heard from across the abyss of time and death: voices of sadness and joy, of experience and life, all bound for whatever reason to a single place, reaching out to those who visit there. At night, however, the voices, and the house itself, take on a more mysterious nature.

In the moonlight, the trees cast eerie shadows against the dark façade of the mansion, and slender, bony branches reach like skeleton fingers from out of the Stygian realms and into the foreboding sky. Owls cry in the distance as the wind rustles the leaves like rattling chains along old brick pathways. Faint, flickering lights occasionally glow from behind wavy, ancient glass—then mysteriously go out. A crow chimes from the rooftop. Shutters creak on rusted hinges. A grandfather clock chimes from somewhere deep within. The grass on the front lawn sways like an endless dark sea. A fence surrounds the property. Is it there to keep people out or to keep some thing inside? A huge featureless behemoth against the evening sky, the house no longer sits on its hill with dignified reserve but looms on its perch over the civilized world below. With an invisible but ominous grin, it dares the curious to approach and discover its secrets.

The spookiest story about Woodlawn involves a well located in the basement of the south side of the building. For whatever reason, reports of unexplainable occurrences seem to spike when the lid to the well is brought down. Writer Buzz McClain suggested this could be a "Well of Souls" in a 1989 article for the *Fairfax Journal*. And Brian Taylor Goldstein wrote a chapter for *Ghost Stories of Woodlawn Plantation* about the phenomenon.

"According to legend, homes or structures built atop wells are inevitably haunted," wrote Goldstein. "This is because wells forge deep into the earth to connect with streams and, for metaphysical, symbolic, and mythical reasons...running water has long been associated with the spirit realm."

Goldstein explains that this is one reason why wells were often located outside or in separate well houses before the days of indoor plumbing. But some houses were constructed over wells anyway, perhaps displaying a preference for convenience over superstition. This is what happened at Woodlawn, where a well was built into the floor of the hyphen connecting the main house to the south wing. Apparently, this well may be some kind of portal to the underworld.

"When a well is open, spirits can freely pass between the water and the house. When the well is closed, however, spirits supposedly become confused, disoriented, and occasionally angry and violent," Goldstein wrote. "This frustration causes them to materialize and search throughout the building for an alternative means of returning to their world."

Most of the time, the lid to the well has been left open. But when it's closed, strange things happen at Woodlawn. In fact, Goldstein explains, more than half of the reported ghostly sightings have taken place when the lid was closed. In some cases, objects that have been placed on the lid have come crashing to the floor overnight. These days, the well is left open permanently with a clear Plexiglas cover.

It's important to note, however, that this has not brought the incidents to a close. In fact, strange things have happened all over the house.

One of the upstairs bedrooms known as the Lafayette Room has been the scene of mysteriously moving furniture and candles inexplicably lighting and extinguishing themselves. One story from the 1930s involves a baby being moved by someone—or some*thing*—from the cradle to the dresser. Some tourists viewing the room have reported having trouble breathing here, and one of Woodlawn's groundskeepers saw a person standing in the window when the house was closed and the alarm activated.

Then there's Lorenzo's Room, located on the top floor to the left of the center staircase that was once home to Lorenzo Lewis. This has also been the scene of strange happenings from time to time. The list includes a staff member feeling a tap on the shoulder only to discover that nobody was there. And there was also the time on New Year's Day 1992 when the doors of the armoire swung open by themselves.

An upstairs corridor in the south wing has a door that's been known to close and lock itself, sometimes at inappropriate times. On one occasion, a residential employee decided to take a quick shower in the south wing's hall bath before going to bed for the evening. After his shower, wearing only a towel, he began walking toward his bedroom through the corridor when he realized that the door had mysteriously closed and locked itself. He tried the knob several times, eventually leaning into the door. But it would not budge. Unwilling to set off the motion alarm in the museum, he resigned to spend the evening there and wait for help in the morning. Until he tried the door again. This time, for reasons unknown, it was no longer locked.

The center hall is another part of Woodlawn known to be haunted. Its majestic proportions evoke the grandeur of life as Martha Washington's granddaughter. But there's a dark undercurrent here, one with animal

The center hall has been the scene of strange animal instincts. *Library of Congress.*

spirits and unexplainable forces at work. People have been known to catch a glimpse of figures moving on the staircase, and photographs taken here somehow feature strange and mystifying swirls of smoke. And something about the stairwell continually frightens cats.

"Many of Woodlawn's feline pets, past and present, have shown a strong dislike for the center hall," wrote Judy McElhaney. "They avoid it as much as possible and become terribly frightened and agitated when carried through the area."

In a chapter about the center hall, McElhaney recounts the tale of a cat named Samantha. Every time Samantha got near the stairwell, she would get angry and begin hissing. Her head would always focus on the same spot as her ears darted back and the growling started. She once clawed her way out of the arms of a superintendent of buildings who was trying to carry her through the area. And, on another occasion, Samantha was purring in the arms of a director until they reached the stairwell, when the growling and hissing started all of a sudden. Quickly, the director darted into the Lewis Dining Room and the purring started again.

"What had Samantha sensed in that hallway?" McElhaney wondered. "Could her strange reaction be to something that happened at the turn of the century?"

Perhaps the strange animal spirits are from the era when Paul Kester lived here with sixty-seven cats. Or perhaps it has something to do with Otto, the large German Shepherd owned by Senator Underwood. Otto was known to growl softly at strangers who got too close to him. Either of these could be an explanation for Samantha's behavior. Then again, it could be something else altogether.

These are only some of the stories from Woodlawn, which is teeming with weird stories and unexplainable events. This is a historic plantation estate where lights turn on and off by themselves. Doors won't stay shut, and candles seem to have a mind of their own. Could it be that all these stories are the product of active imaginations? Is it possible that Woodlawn's reputation as a haunted house has created a willing suspension of disbelief in which every stray noise is perceived as a ghost? Nobody knows for sure, yet people have speculated for years. Perhaps the house is haunted—or maybe not.

"The most compelling evidence for ghosts is their appearances and sightings," Goldstein wrote. "Of these, Woodlawn has many."

Over the years, tour guides have reported hearing footsteps in empty rooms and music from an unknown source. Some have reported walking through "cold columns" in which the temperature of the air unexpectedly drops to freezing levels and then suddenly returns to normal. They have reported the presence of strange orblike objects appearing in photographs taken inside Woodlawn. Ultimately, they have ended up comforting a good number of frightened visitors who have become spooked by the mansion's unseen inhabitants.

"There's definitely a sense that more is going on than meets the eye," said museum administrator Michael Banton. "It's like there's this sense that someone else is here—not a frightening sense, necessarily."

CHAPTER 10

BAT IN THE BELFRY

ALEXANDRIA'S TOWN SQUARE SEES
ALL THE ACTION

Visitors to Alexandria are inevitably drawn to Market Square, that red brick public space framed by City Hall and some of the city's most historic buildings—the Carlyle House to the east and Gadsby's Tavern to the west. But one feature dominates the landscape: that clock tower with a steeple on top rising above Royal Street. This is the scene of our next legend.

Some say that the clock tower is haunted by a devil-bat. Rumors have circulated for years about the devil-bat. The first documentation of the menace comes from a 1975 publication titled *Alexandria Ghost Stories*, published by the Alexandria Youth Bicentennial Committee. In a section titled "Teller of Tales and the Devil-Bat of Market Square," writer Eric Segal recounts his interview with a quintessential Old Town character by the name of Louie Robert. Puffing on a pipe, the old man recounts the story to Segal with an attractive moodiness in the muted light of his framing shop.

"Now, as his tale proceeds, we recognize the potent air around him reminiscent of years long ago confined to the prison of dusty history tomes," Segal muses. "Years before mass communication and written anthologies, years when stories passed from mouth to mouth, years of folklore."

Segal describes Robert as a character out of a movie, short and slightly hunchbacked with an aura of profound worldliness. His face was tanned and leathery, draped by a mop of white hair. He was, in Segal's words, "weathered in a manner most will never understand." Here, in Robert's darkened and smoke-filled frame shop on Cameron Street, is where we meet the devil-bat.

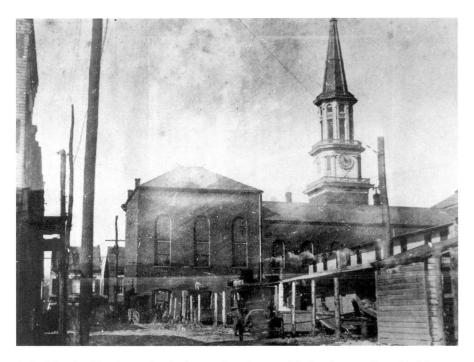

A devil-bat is said to haunt the clock tower looming over Market Square. *Alexandria Library Local History Special Collections.*

"Well, I guess one of the oldest stories goin' back I don't know how long is the story of the devil bat of Market Square," Robert told Segal. "They say it lives up there in the belfry of City Hall. I don't know much about the story, and I don't know if anyone says they seen it. But I *thought* I saw it once."

Along with Segal, we pull up a chair to soak in the wit and wisdom of this grizzled old man, a relic from another time who reveals long-suppressed secrets about City Hall. He points and gesticulates in the subdued glow of his framing shop, revealing long-lost secrets and half-remembered dreams. He squints, swears and paces. Every now and then, he pauses from his storytelling to refill that battered old pipe with tobacco. We become caught up in his spell.

"An unusual character, probably the best way to describe him is to compare him to his well-used pipe," Segal explains. "Both are dark, rather old, with a few marks of age, and yet still, keen as ever."

The way Robert tells the story to Segal, the devil-bat is as old as Alexandria itself. He was there when George Washington surveyed the city streets in

1749. He was there when Benjamin Henry Latrobe designed the famous clock tower for City Hall in 1817. And he stuck around when the belfry was destroyed by fire and replaced by a replica in 1871. Like many aspects of this seaport city, the origins of the devil-bat are tied to the river.

"No, twasn't long ago that the North Boat used to come to port in Alexandria," rasped Robert. "It came late at night, about eleven or twelve."

Robert recalls the mayhem and chaos that erupted each time the drunken "North Boat" arrived at the waterfront. Hundreds of passengers were singing as the boat rocked back and forth at the dock, its lights brightening the dark sky framing Maryland and the District in the distance. The intoxicated men would descend on Alexandria with a drunken vengeance, shouting into the night air and generally raising hell as they broke windows along King Street.

"Something about that boat made those guys really wild," Robert explained to Segal. "I don't now what it was, but they always came on shore a little more than drunk."

One night, the North Boat arrived, and the usual suspects began tearing through town. But this was not a normal drunken rampage along King Street. The crowd was even rowdier than usual, and it was growing more restless by the moment. As the evening went on, the violence escalated. The rioting crowd caroused the streets of Old Town, breaking windows and screaming wildly. The scene threatened to descend into anarchy. Looking to find out what all the ruckus was about, Robert walked out onto King Street to get a firsthand glimpse of the rioting crowd.

"I heard 'em saying something, believe it or not, about tearin' down City Hall," Robert said. "All of a sudden, for some reason, I still don't know why, I said something like, 'Devil-bat, devil-bat, keep this crowd back!'"

Robert said he didn't know that anything would happen when he said this. But, of course, something unexplainable took place. From out of nowhere, according to Robert's story, a giant devil-bat appeared. He saw the devil-bat with his own two eyes, flying close to the ground and zinging toward the frightened crowd of drunken men. As the crowd got closer to City Hall, the devil-bat hid itself behind the door under the clock tower.

"I didn't know what to expect then," said the old man. "But you can bet that I wasn't goin' anywhere 'til I found out."

The mob got closer and closer to City Hall as the devil-bat lay in waiting. Just as the crush of drunken revelers reached the building, the devil-bat pounced. It shot out of the doorway at full speed toward the crowd. Seeing this frightening black-winged creature, some scampered away into the darkened alleyways of Old Town. Others sailed away. The North Boat

eventually stopped making appearances in Alexandria, and the devil-bat was credited with saving City Hall from certain destruction.

"I was scared, but I was curious too, so I checked to see what it was and there in the middle of the street was the biggest darn skunk anybody ever saw," Robert said. "Some say that proves the devil bat doesn't exist; it's just some skunk. But other say that it proves it does, it just turned into a skunk to protect its old home. I'm not sure, but, as far as I know, that's the closest anyone's ever come to really seeing it."

City Hall looms large in the imagination of anyone who has ever spent any time in Alexandria. Its rich Second Empire architecture makes an impression, and milling around Market Square for a few moments will give you a flavor of the city and its people. This has been the scene of all of Alexandria's public events, everything from floggings to festivals. From the Market Square side, the building looks to be of colonial vintage. But that's a 1960s façade. The other side of the building, facing Cameron Street, is more authentic to the true nature of the original 1880s architecture.

But that's the modern City Hall. In reality, a dozen or so public structures have come and gone over the years, many of which remain dim memories tucked away in the dusty archives of the city's special collections. There, in that famous clock tower featured in postcards and tourist brochures, lurks a dark secret.

The devil-bat haunts City Hall.

From the beginning, this block was to be the heart of the city. When the streets were originally surveyed by a team including a young George Washington, the center of the grid was the intersection of Cameron and Fairfax Streets—indicating the significance of Lord Fairfax, who was also the Baron of Cameron. At the southwest corner, an acre was set aside for a public marketplace. This was a feature of urban design prevalent in English and French culture, where the Crown designated "market towns" and enjoyed a local trade monopoly.

So the block bounded by King, Royal, Cameron and Fairfax Streets has always been the center of gravity in Old Town—even from the very beginning, when part of the block was set aside for public use at the original auction in 1749. The next year, the city's trustees announced a lottery in the *Maryland Gazette*, "the money arising therefrom to be applied toward building a church and market house." The Fairfax Country Court met here from 1752 to 1800, and the Hustings Court met here from 1780 to 1801.

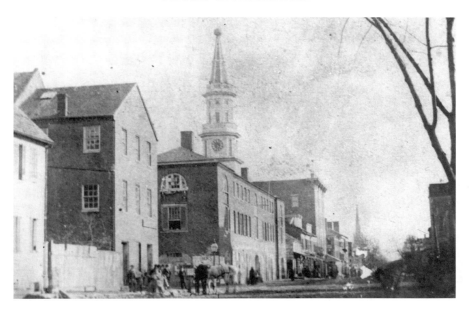

The original steeple at City Hall was designed by architect Benjamin Henry Latrobe. *Alexandria Library Local History Special Collections.*

First was the original market house, constructed in 1750 and fenced in two years later. Then there was the Fairfax County Court, constructed in 1752. A schoolhouse and town hall were built in 1759, and a brick prison was constructed in 1763. Expensive repairs were required in 1765. Then there was the addition of the Friendship Volunteer Fire Company in 1774 and the Sun Fire Company in 1775. In 1782, a building was erected to serve as the Hustings Court.

Pretty soon, the block was becoming cramped and overused. By 1784, Alexandrians were petitioning for a new building that could serve as both a market house and courthouse. One was constructed the following year, a narrow seventy-eight- by twenty-four-foot edifice along Cameron Street near the intersection with Royal Street.

By 1817, Alexandria finally got the building it had been waiting for, a massive three-story brick building with a steeple designed by Benjamin Henry Latrobe. Known by some as the "Father of American Architecture," Latrobe is probably best known as architect of the Washington, D.C., Capitol and White House. His tall-steepled tower featured a town clock and ringing bells, keeping Alexandrians of the era on time for their appointments with government officials and merchants.

The 1817 building was connected to the old 1785 structure, which was still in use. The new structure was a 154-foot-by-24-foot wing along Royal Street. Together, the buildings formed a grand complex that was considered one of the finest municipal buildings in America, a jewel of public stewardship unrivaled in Georgetown, Washington or Baltimore.

The Masons used part of the third floor for a meeting room. Other rooms were used by the mayor, the court, the clerk's office, the board of aldermen and the Exchange Coffee House. The first floor was dominated by a market, a place where butchers and hucksters set up stalls under the arches of the Hustings Court. Vendors in the market selling chickens and eggs would squat under a row of mulberry trees. Other items for sale included chinquapins, persimmon beer, apple pone, greasy brown puffs and something called "Washington Pie."

The block was bisected by the appropriately named Market Alley, which ran from Royal to Fairfax. At the center of Market Alley was the whipping post. Sharpshin Alley extended at a right angle from Market Alley from the market toward King Street. The exact origin of the word "sharpshin" is unknown. But Alexandria historian Ruth Lincoln Kaye has a possible explanation in her classic work, *Legends and Folk Tales of Old Alexandria*.

The way Kaye describes Sharpshin Alley, it was always buzzing with activity. Vendors were always in the alley trying to sell fish from the Potomac River or fresh flowers from the gently rolling hills of Northern Virginia. Here is where the town folk would buy chickens, pigs, garden produce and freshly ground flour. This is where one would find the pillory, the whipping post and the jail.

"The origin of the name Sharpshin (some say Shinbone) Alley lay in the fact that coins as a medium of exchange were often in short supply following the Revolutionary War," Kaye wrote. "They were therefore cut in four pieces to extend their use. The sharp edges of the coins often cut through the pockets of clothing and fell to the cobblestone, skinning the shins en route."

The Great Fire of 1871 changed City Hall and Market Square forever. The date was May 18, 1871. That's when a disastrous fire completely destroyed the Alexandria courthouse and marketplace. Planning for a new City Hall began almost before the embers went dark. Within a month of the conflagration, the Hydraulion Engine House and the Sun Fire House were demolished to make way for a new municipal building—one that was larger and even grander than the old 1817 structure.

Renowned architect Adolf Cluss was brought on as the architect. An emigrant from Germany, Cluss excelled in the family business. Both his father

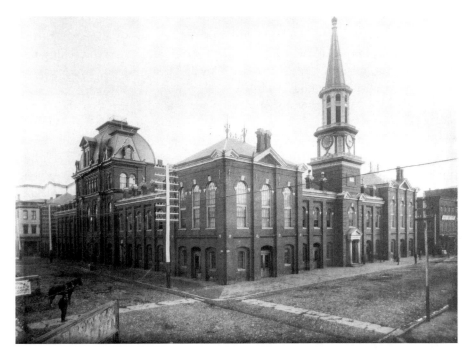

Architect Adolf Cluss designed a replica of Latrobe's steeple after City Hall was destroyed by fire in 1871. *Alexandria Library Local History Special Collections.*

and his grandfather were architects, and Cluss clearly benefited from being raised in an atmosphere that valued the art and science of structural design. In addition to designing Alexandria's City Hall, Cluss also built the Untied States Masonic Temple, the United States Department of Agriculture and the now demolished Center Market located on the block now dominated by the National Archives.

In 1961, architects Robert Willgoos and Dwight Chase designed a southern addition filled in the yard that has long served as Market Square. Then in the 1980s, the firm of Neer and Graef gutted the building and created the interior space that modern-day visitors experience when they visit City Hall. Has the devil-bat been lurking about this whole time, waiting for the right time to protect its turf the way it did when the rowdy crowd from the North Boat threatened to tear down City Hall?

Consider the evidence. Strange forces always seem to be at work here. Deals are struck and decisions are made under the clock tower haunted by the devil-bat. Sometimes dreams are realized here. At other times,

aspirations are smashed to pieces. Reputations are undermined in furtive sideways whispers for some, while others use this venue as a launching pad for other positions at the state or federal level. This is a place where secrets are stored away, just like that devil-bat lurking in the clock tower.

"I don't know too many decisions that were made here that didn't rely on blood money," explains former Alexandria City Councilman Winfield McConchie. "That's how it works at City Hall."

First elected in 1970, McConchie witnessed the final days of "urban renewal." That was the euphemistic phrase used by city leaders to explain the reason for demolishing several blocks of historic buildings on King Street. It began with either side of Sharpshin Alley, demolishing everything along King Street from Royal to Fairfax. But that was just the beginning. Several more blocks were razed and replaced by modern buildings.

"The old buildings were run-down and dilapidated," said McConchie. "Urban renewal was the turning point. There was no building that was torn down that was worth saving."

But it was a mixed blessing, McConchie explained—with dark secrets waiting in the shadows just as the devil-bat nestles itself in that famous clock tower. Some of Alexandria's elected officials from that era were rumored to have a personal stake in the real estate developed by urban renewal. They apparently bought low and sold high, McConchie explained. Knowing that the value of the land would drastically increase when approval was granted, they made a fortune gutting Alexandria of its old-fashioned painted ladies. Even if it was accomplished with shady deals and backroom negotiation, McConchie says that the effort was worth it in the long run.

"Look at King Street now," he explains. "Would you want it full of pawnshops and dilapidated old buildings and businesses that weren't making any money?"

Everybody has his or her own view of what the devil-bat is, exactly, and how it haunts the city. Some say that it's the burden of high taxes, a chronic concern of local governments across America. Others say that it's the stranglehold developers have on elected officials, another frequent bugaboo at the municipal level. For some, the devil-bat of Alexandria is directly tied to its growing popularity. The more attractive the city becomes, the more expensive the land becomes. That means people on the bottom end of the socioeconomic ladder get the shaft.

This was certainly the devil-bat that Mitch Snyder had in mind when he occupied the City Council chambers during a dramatic standoff in February 1987. That was a time when more and more apartments were

King Street was run-down and dangerous before urban renewal. *Alexandria Library Local History Special Collections.*

being converted into condominiums, pushing out the low-wage renters with high-salaried yuppies looking to live inside the Beltway. When an Arlandria apartment complex announced its intention to convert itself into condominiums, Snyder put together a group of protesters and stormed City Hall during a public hearing one Saturday.

Council members had just taken a break for lunch when it happened. Snyder and his group of protesters stormed into City Council chambers and announced that they were in control now. The rowdy group sat in the council members seats' and began going through their things. One of them stole City Manager Vola Lawson's name tag. Another rummaged through Councilwoman Del Pepper's purse.

In the adjoining council workroom, the city's real leaders weren't quite sure what to do. Mayor Jim Moran wanted to go out and directly confront them. But Lawson urged patience, imploring the redheaded Irish mayor to cool his temper until the cops arrived. Within minutes, the boys in blue arrived, and the protesters were removed from the chamber. The siege of 1987 ended without violence.

"About the worst thing that happened was that they ate Del's cookies," recalled Moran, who now represents the city in Congress.

Another devil-bat haunting that the city has is not a bat at all. It's a dog. Alexandria is known for being a dog town. During one discussion of a "pooper-scooper" ordinance, dozens of dog owners signed up to speak at a particularly lengthy public hearing. Things were getting quite dull, recalled legislative aide Sharon Annear, when a practical joker entered the name Alfred Arf on the list of speakers to weigh in on the issue. Mayor Charles Beatley called the name, and a poodle bounded up the aisle toward the dais.

"It brought the house down," said Annear.

Haunted by generations of conflict and resolution, City Hall is teeming with devil-bats of all shapes and sizes. Some are of the large-wing variety, posing grand and existential threats such as flooding or explosions. Others may seem trivial to some while sparking great emotion in a select but vocal few, forever nipping at the heels of municipal governance. Caught in the middle are an ever-changing cast of city officials and elected leaders, moving through the landscape of time as if cast in a haunted drama starring a colonial city and its creepy bloodsucking pet. Like any other representative sample, some of these folks are embezzling scoundrels, while others serve the community interest.

Looming over it all is the devil-bat, waiting for the next moment to strike.

BIBLIOGRAPHY

Alexandria Association. "Our Town: 1749-1865, Likenesses of This Place and Its People Taken From Life by Artists Known and Unknown." Alexandria, VA: Alexandria Association, 1956.

Alexandria Gazette. "All Hallow E'en." November 1, 1881.

———. "Fall From Fourth Story of Braddock House Kills 'Pat' Buckley." November 18, 1912.

———. "Fatal and Melancholy Affair." June 29, 1868.

———. "A Fatal Fall." August 7, 1905.

———. "Hallowe'en." October 31, 1882.

Barber, James. "Alexandria in the Civil War." Lynchburg, VA: E.E. Howard, Inc., 1988.

Blake, Rich. "Area Haunts Rife with Things That Go Bump in the Dark." *Alexandria Gazette Packet*, October 29, 1992.

Cox, Ethelyn. *Historic Alexandria Virginia Street by Street.* Alexandria, VA: Historic Alexandria Foundation, 1976.

Cressey, Pamela. "The Case of 414 Franklin Street: A Case Study of Discovery and Dialogue." *Fireside Sentinel*, December 1989.

Edwards, Jolane. "There Are Ghost Tales in Alexandria." *Mobile Press Register*, October 31, 1970.

Ellis, Joseph. *His Excellency: George Washington.* New York: Knopf, 2004.

Fauber, J. Everette, Jr. *The John Carlyle House: Alexandria Virginia Restoration Report for the Northern Virginia Regional Park Authority.* Forest, VA: Fauber Garbee, Inc., Architects, July 1980.

Feldhaus, Hal. "Things That Go 'Bump' in Old Town." *Old Towne Crier*, October 1985.

Geddes, Jean. "Story of Ghost of Red Hill Still Intriguing to People in Alexandria." *Northern Virginia Sun*, August 14, 1967.

Graham, Martha. "Ghosts Have Favorite Haunts in the City." *Alexandria Port Packet*, October 24, 1979.

———. "The Watchman's Back!" *Alexandria Port Packet*, December 19, 1979.

Hambleton, Elizabeth, and Marian Van Landingham, eds. "A Composite History of Alexandria." Alexandria, VA: Alexandria Bicentennial Commission. 1975.

Jackson, Donald, and Dorothy Twohig. "The Diaries of George Washington." Vol. 6. Charlottesville: University Press of Virginia, 1979.

Jacobson, Abbe, and Elizabeth Stubbs. "Eeeeeeeeee! (Gasp) Something Wicket This Way Comes." *Alexandria Gazette Packet*, October 31, 1991.

Kaye, Ruth Lincoln. "Alleys and Courts of Old Town Alexandria, Virginia: 18th Century to the Present." Unpublished manuscript, May 1997.

———. *Legends and Folk Tales of Old Alexandria*. Alexandria, VA: privately published, 1975.

———. "More on Spring Gardens." *Fireside Sentinel*, November 1989.

Leider, Bob. "North Ridge's Ghosts: Harmless, Mysterious." *Alexandria Gazette*, March 25, 1981.

Lide, Frances. "April in Alexandria: Time to See Ghosts." *Washington Post*, April 5, 1956.

———. "Ghosts Adds Fillip." *Sunday Star*, October 3, 1965.

McElhaney, Judy. *Ghost Stories of Woodlawn Plantation*. McLean, VA: EMP Publications, 1992.

McGroarty, William Buckner. "The Story of Colonel Michael Swope and His Home in Alexandria." *Alexandria Gazette*, September 27, 1934.

Miller, Michael. *Alexandria [Virginia] City Officialdom, 1749–1992*. Bowie, MD: Heritage Books, 1992.

———. "Chronology of Events at Yates Gardens, 414 Franklin Street." Alexandria Library, Special Collections, unpublished manuscript, April 14, 1989.

———. "Death Stalks the Carlyle House." Alexandria Library, Special Collections, unpublished manuscript, 1989.

———. "Spring Gardens: An 18th & 19th Century Pleasure Glade." *Fireside Sentinel*, May 1989.

————. "Spring Gardens Revisited." *Fireside Sentinel*, November 1989.

Moore, Gay Montague. *Seaport in Virginia*. Richmond, VA: Garrett and Massie, Inc., 1949.

Morrill, Penny. "Alexandria, Virginia's Market Square." Alexandria Library, Special Collections, unpublished manuscript, 1989.

Morvay, Joanne. "George Washington Ate and Drank Here." *Alexandria Journal*, January 6, 1989.

Munson, James. "Col. John Carlyle: A True and Just Account of the Man and His House." Alexandria, VA: Northern Virginia Regional Park Authority, 1986.

North Ridge Citizens' Association. *North Ridge Lore Revisited*. Alexandria, VA: North Ridge Citizens' Association, 2000.

O'Brien, Cyril. "Spirits of Suburbia: Ghostly Accounts Abound Around the Beltway." *Virginia Journal*, October 31, 1986.

O'Hanlon, Ann. "In Alexandria's Old Town, Playing Host to the Ghosts." *Washington Post*, October 30, 1999.

Owen, Walton H., ed. *Life of James W. Jackson, the Alexandria Hero, The Slayer of Ellsworth, the First Martyr in the Cause of Southern Independence*. Originally published Richmond, VA: West & Johnson, 1862. Republished Falls Church, VA: Confederate Printers, 1985.

Pope, Michael Lee. "Development Uncovers Urban Plantation." *Alexandria Gazette Packet*, August 25, 2005.

————. "'Fatal and Melancholy Affair.'" *Alexandria Gazette Packet*, February 7, 2008.

————. "From Marshall to Monaco." *Alexandria Gazette Packet*, February 27, 2008.

————. "The Haunted Mansion." *Alexandria Gazette Packet*, October 18, 2007.

————. "The Other British Invasion: War of 1812 Reenactment to Interpret 1814 British Occupation of Alexandria, D.C." *Alexandria Gazette Packet*, August 9, 2007.

————. "The Troublesome Tombstone: The Most Famous Grave in Alexandria Is Also its Most Mysterious." *Alexandria Gazette Packet*, October 26, 2006.

————. "Who Was She? Female Stranger's Grave Continues to Spook Old Town." *Alexandria Gazette Packet*, October 27, 2005.

Powell, Mary. *The History of Old Alexandria, Virginia: From July 13, 1749 to May 24, 1861*. Richmond, VA: William Byrd Press, Inc., 1928.

Prowell, George. *York County and the Early Wars of Our History*. York, PA: C.J. Hall and J.P. Lehn, 1920.

Reed, Robert. "Deck the Halls, Historically." *Alexandria Gazette Packet*, December 16, 1988.

Revis, Sarah. "Commentary on Spring Gardens." *Fireside Sentinel*, November 1989.

———. "Spring Garden Farm and Tavern." Alexandria Library, Special Collections, unpublished manuscript, February 1986.

Segal, Eric. "Alexandria Ghosts." Alexandria, VA: Alexandria Bicentennial Youth Commission, 1975.

Seng, Marjorie. "The Spirits of Old Town: Alexandria Revisited." *Northern Virginian*. Fall 1983.

Soper, Angela. "Old Town the Ghost Town." *Alexandria Gazette Packet*, October 27, 1989.

Spellman, James David. "They Say it Happens in the Best of Houses." *Washington Post*, October 28, 1977.

"The Story of the Female Stranger." Alexandria, VA: Gadsby's Tavern and City Hall, Inc., n.d. Alexandria Library, Special Collections.

Taylor, L.B. *Ghosts of Virginia*. USA: Progress Printing, 1993.

Toups, Catherine. "Still Asking: Where Was George?" *Alexandria Journal*, March 9, 1989.

Washington Star News. "Condos on Old Fort Site." October 14, 1973.

ABOUT THE AUTHOR

Michael Lee Pope is an award-winning journalist who lives in Old Town Alexandria. He has reported for the *Alexandria Gazette Packet*, WAMU 88.5 News, the *New York Daily News* and the *Tallahassee Democrat*. He's also a ghost tour guide who has led tourists and school groups through the streets of Old Town since Halloween 2004. A native of Moultrie, Georgia, he grew up in Durham, North Carolina, and graduated high school in Tampa, Florida. He has a master's degree in American Studies from Florida State University and lives in the Yates Gardens neighborhood with his lovely wife, Hope Nelson, and his cat, Lucky Abigail Nelson-Pope.

Visit us at
www.historypress.net